JOURNAL WITH PURPOSE

LAYOUT IDEAS

101

Over **100** inspiring journal layouts plus **500** writing prompts

HELEN COLEBROOK

DAVID & CHARLES

www.davidandcharles.com

Contents

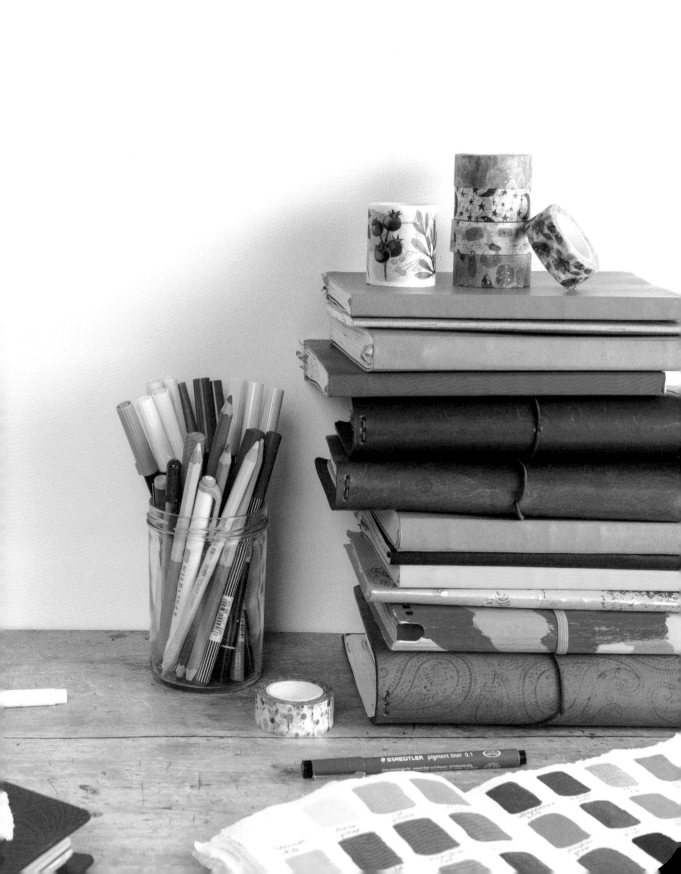

Welcome

I am so excited to share this ultimate journaling guide with you. Whether you are completely new to journaling, or looking to develop and deepen your journal practice, this book will give you plenty of new ideas for topics to write about, different journaling layouts and stacks of creative inspiration.

This is the book that I wish had existed when I first started journaling. I was not sure what I wanted to write about or how I wanted to document my days, so everything in this book is designed to give you inspiration taken from the different styles and techniques that I have learnt over the years.

Your journal can be used in so many different ways, like planning out your dream life, getting thoughts out of your head, organizing your workload, documenting daily life and focusing on your health and well-being, along with being a wonderful break from the digital world.

Keeping a journal is linked closely to the act of mindfulness, as it enables you to engage with and explore your thoughts, while still focusing on the present moment. The simple act of picking up a pen and writing can help you to feel more relaxed and pause the continual swirl of activity in your mind, giving some useful structure to your thoughts and feelings.

By reliving positive experiences in your journal, you can help to boost your mood and build self-confidence. Writing things down has also been linked to improved memory, and it helps you to commit to your goals in a way that typing alone often cannot achieve.

My biggest hope is that this book acts as a springboard for you in your own journaling routine. You can either copy my layouts exactly, or use them as inspiration to create something that feels right for you and your lifestyle.

One of the great things about journaling is that there are absolutely no rules. You cannot do it wrong! So please relax and enjoy the journey of self-discovery and the many benefits that come with regularly taking time out to document and create in your journal.

Helen

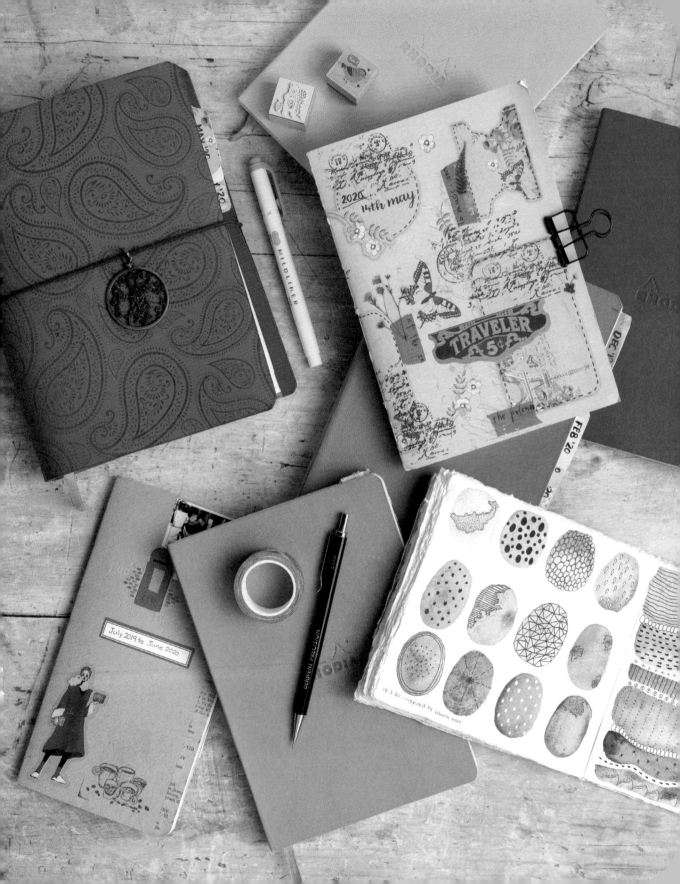

Tools & Materials

You don't need a lot of special equipment to start journaling – just a few stationery supplies that will grow over time. A good-quality journal is really important, with paper that can handle a wide range of inks and colour without bleeding onto the next page. The things I keep close to hand are shown here, but you will soon find your own favourites.

Coloured pencils

Fineliners

Highlighters

Washi tape

Erasers

Drawing pencils

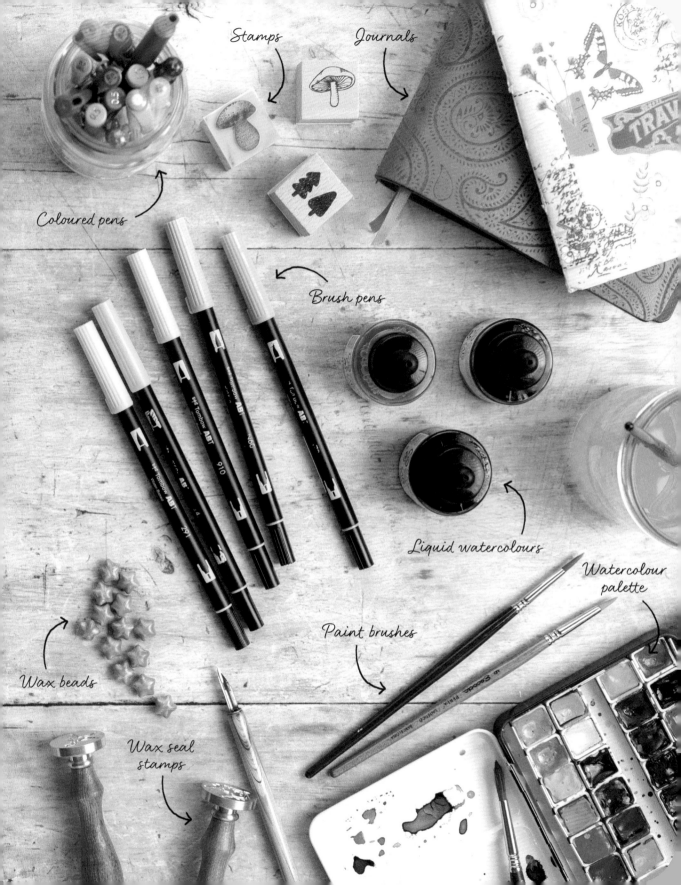

Stamps

Journals

Coloured pens

Brush pens

Liquid watercolours

Watercolour palette

Wax beads

Paint brushes

Wax seal stamps

Be Grateful

One of the most significant benefits that I have experienced from keeping a journal is the ability to focus more easily on the good things in life. Every month I set up some gratitude pages in my journal, ready for me to write in every evening. Not only is it a lovely habit to establish, but I also find that it encourages me to look out for those positive moments throughout the day.

Sometimes, there are really significant events that I can record, but most days, it is more a case of simply recognizing the little things that can so easily go unnoticed. Examples of my gratitude entries include: the smell of fresh coffee, chatting with a friend, sunshine coming through the window or not getting stuck in traffic.

It is easy to fall into the trap of saying we have had a bad day, and it is definitely true that some days are better than others, but I have yet to experience a day where there has not been at least one or two good things that have happened.

Not only does it help to boost your mood when you focus on the positives, but you also get the extra benefit of being able to read back through your journal pages at any time, as a really happy reminder of all the good things.

Keeping a gratitude journal can feel a little false at first, particularly if you are used to focusing more on things that are troubling you. It is worth sticking with it for a whole month, though, to see how much more naturally it comes to you over a period of time.

There are lots of fun ways to set up gratitude pages, and I have included some of my favourite methods in this section.

Layout #1

Use brush pens to add different coloured lines to your pages.

Doodle leaf elements into your journal.

Family

Laughter

Watching old movies

Gratitude

Sunshine coming in through the window | Reading a really great book | Freshly brewed coffee | Seeing my family | Going for a walk along the beach

Layout #2

Use watercolour paints to create fun writing spots.

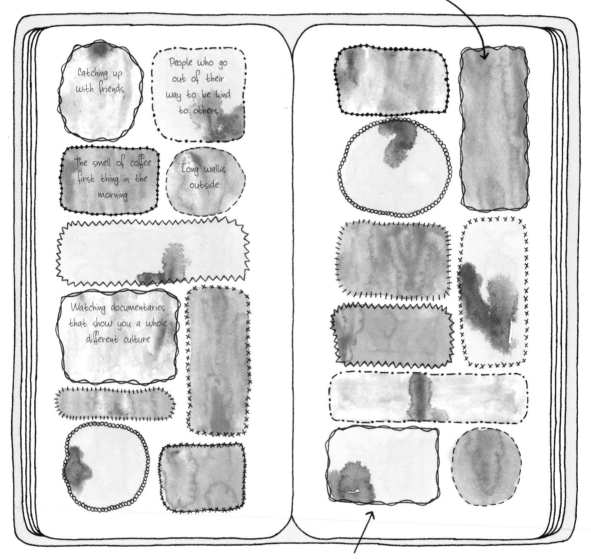

Catching up with friends

People who go out of their way to be kind to others

The smell of coffee first thing in the morning

Long walks outside

Watching documentaries that show you a whole different culture

Doodle squiggly lines around your painted writing spots, for extra decoration.

Layout #3

Doodle some simple flowers
to create a border.

Having a shelf full of books

Making it to the weekend

My favourite song on the radio

Use watercolour paints to create bright
coloured lines. Write something you are
grateful for on each of these lines.

Layout #4

Doodle different banners and stationery items that you can write on.

Layout #5

Tear up pieces of scrapbook or wrapping paper. Glue these to your pages and draw stitch marks over the edges to create a patchwork effect.

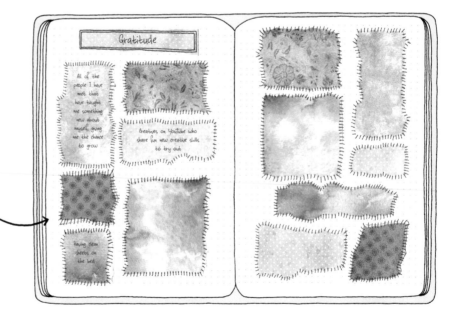

WRITING PROMPTS

When you are having a tough day, it can sometimes be hard to change your mindset back to gratitude. However, it is on these days in particular that you will gain the most benefit from doing so. If you are struggling for inspiration, these prompts should help you to focus on the good things.

1. Who are you most grateful for in your life right now, and why?

2. What lessons are you grateful to have learnt through difficult times?

3. Which activities do you most enjoy doing?

4. What household items make your life easier?

5. Which TV programmes or films do you most enjoy watching?

6. Write down the places you are most grateful to have visited and why.

7. What are you most thankful for today?

8. Which moments made you smile?

9. Write down the name of a song or musician that always makes you feel better.

10. Which foods do you most enjoy eating?

11. What sounds have you heard today that make you happy?

12. Are there any books that have had a really positive impact on your life?

13. Which comedians always make you laugh?

14. Write down something about your body that you are thankful for.

15. Who has helped you with something important?

16. Which memories make you smile?

17. What is your favourite smell, and why?

18. What are you most looking forward to?

19. When you are outside, or looking out of your window, what do you most enjoy seeing?

20. What positive impact were you able to make on the world today, even if only in a small way?

21. What opportunities do you have in your life that some people do not?

22. What choices do you have the freedom to make?

23. Which small pleasures mean the most to you?

24. What do you love about this time of year?

25. What thing do you most enjoy about your job?

26. Where do you feel safe?

27. Think about a goal or dream you have set for yourself. Write down what makes you grateful to have this particular goal to work towards.

Track Those Habits

I often use my journal to help me to focus on personal development and move closer towards my goals. These goals can seem so far away - sometimes even unachievable - so I find it really beneficial to focus on the habits that will take me closer towards reaching them instead.

To help with this, I always keep a monthly habit tracker in my journal, and I often keep a mini weekly one, too. Before each new month begins, I take some time to reflect on how things have been progressing. I then set out the habits that I think will be useful for me to put in place or maintain over the coming weeks.

This feels much more manageable than just focusing on big goals and not being sure how to get there. For example, if I want to complete a really big project, I think about the habits that will help me to achieve that. This could be areas such as getting a good night's sleep, staying focused, daily reading or research into my topic, eating healthily to improve my energy levels and staying well organized. I then write these out in my habit tracker and mark them off every evening, which helps me to see that I am making progress.

If you have just one key habit that you want to focus on, you could create a tracker for this, too. Trackers are a great way to keep you "on plan" and also add a lovely creative element to your journal pages.

I always review my habit trackers at the end of each week, to think about any changes that I need to make to my daily routine and structure. I have provided some examples for different ways that you could create a habit tracker of your own. If you are anything like me, adding something to your habit tracker each evening will really help to keep you motivated.

Create a circular habit tracker using a compass. These are great visual trackers if you only have five or six habits that you really want to focus on. Write your habits in each circle of the tracker, add your dates around the outside and then colour in a box each day that you carry out a habit.

Use stickers, ephemera, doodles or washi tape to add some creative fun to your page.

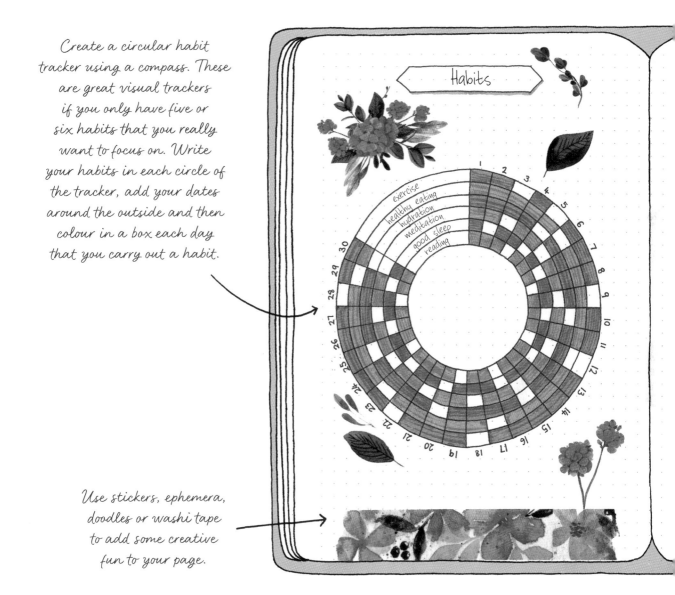

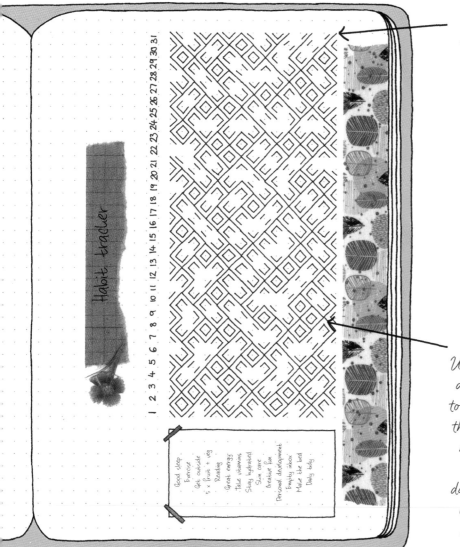

Habit tracker

1 2 3 4 5 6 7 8 9 10 11 12 13 14 15 16 17 18 19 20 21 22 23 24 25 26 27 28 29 30 31

Good sleep
Exercise
Get outside
5 x fruit + veg
Reading
Great energy
Take vitamins
Stay hydrated
Skin care
Creative fun
Personal development
Empty inbox
Make the bed
Daily tidy

If you have several habits that you want to focus on, try creating a horizontal tracker, where you create a really eye-catching pattern if you carry out lots of those habits.

Using the dots on the page as a guide, allocate a column to each day of the month. On the days that you complete a habit, draw three diagonal lines under the relevant date. Alternate the direction of the lines for each day to start building the pattern.

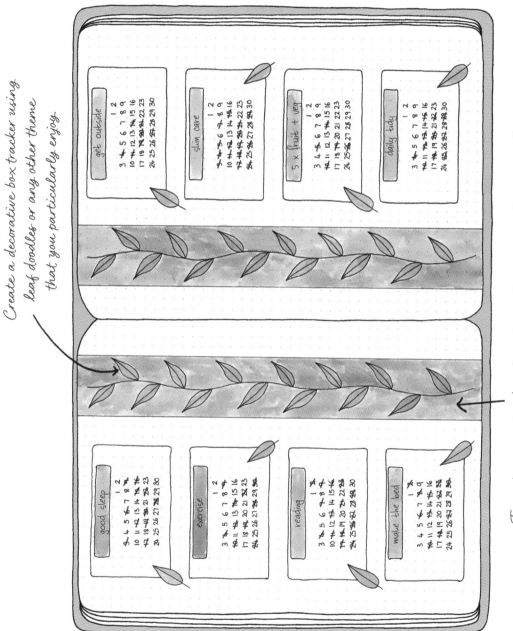

Create a decorative box tracker using leaf doodles or any other theme that you particularly enjoy.

Try using a water-based pen to create a watercolour effect. I used Tombow ABT brush pens to scribble on a cellophane bag, then mixed the ink with water. Then, I used a paint brush to apply the mix to my pages, creating this watercolour effect.

Layout #9

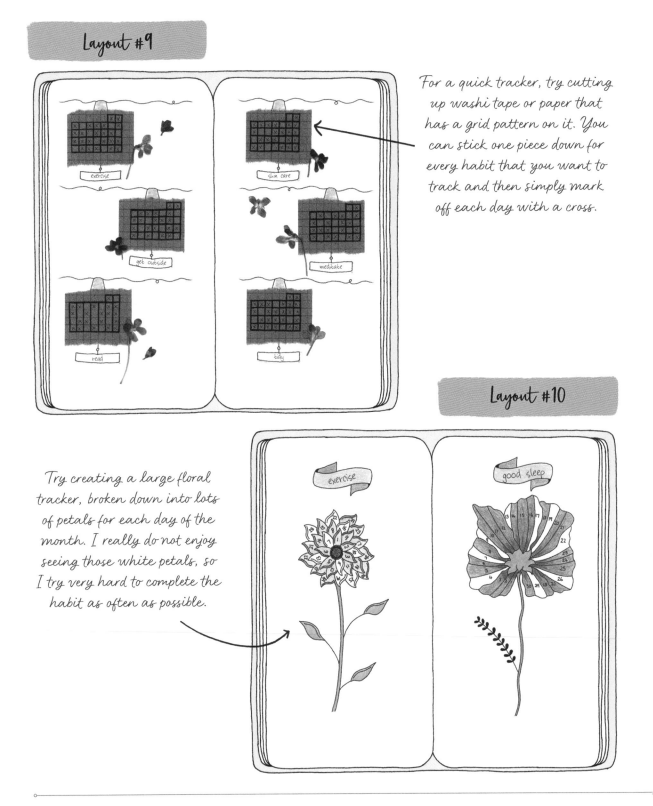

exercise

skin care

get outside

meditate

read

tidy

For a quick tracker, try cutting up washi tape or paper that has a grid pattern on it. You can stick one piece down for every habit that you want to track and then simply mark off each day with a cross.

Layout #10

Try creating a large floral tracker, broken down into lots of petals for each day of the month. I really do not enjoy seeing those white petals, so I try very hard to complete the habit as often as possible.

exercise

good sleep

WRITING PROMPTS

To help to get you started on your habit tracker, have a think about the journal prompts below. It would be really useful to write down your responses in your journal and look back on them in the future.

28. What habits would help you to move closer to your goals?

29. If you could look 12 months into the future, what habits would you be pleased you started today?

30. What habits would help you to improve your relationships with others?

31. What habits have you successfully maintained in the past? How did this make you feel?

32. Do you have any destructive or unhelpful habits? If so, what would the opposite habit to this be?

33. Are there any habits that would help you to improve your health?

34. How do you want to feel?

35. Which habits do you find difficult to maintain?

36. What support could help you to set these new habits in place?

37. Do you have any financial goals? If so, what sort of regular habits could help with this?

38. If you carried out just one habit every day, for 30 days, what difference would it make to you?

39. What habits could help you to build your career?

40. Do you know anyone who is great at carrying out the habits you are trying to implement?

41. What could you learn from them and other people around you?

42. Do you have any creative goals? If so, what regular habits could you form to improve your skills in this area?

43. When is the best time of day for your key habits?

44. What can you foresee that may get in your way?

45. What is the motivation for regularly carrying out these habits?

46. Which habits would be helpful for your self-care?

47. How often do you prioritize the things that are important to you?

48. Are there any great podcasts that focus specifically on a habit you are trying to work on?

49. What bad habits have you tackled in the past?

50. What can you learn from that to help you now?

51. Are there any rewards that you could offer yourself for carrying out a habit for a certain amount of time?

52. Write down a paragraph in your journal, imagining how life will feel when you have successfully established a certain habit.

53. Which small habit could you start with, to help to boost your confidence?

54. How many habits do you think you can successfully focus on at one time?

Monitor Your Mood

△▽△▽△▽△▽△▽△▽△▽△▽△▽△▽△▽△▽△▽△▽

I find that my mood can fluctuate a lot, certainly from day to day and sometimes even by the hour. While this is a natural part of life, I do like to use my journal to track my moods each day and look at what I can do to bring more happiness into my life.

Each month I create a visual mood tracker in my journal, to keep an eye on how I have been feeling. I usually only record one overriding mood for the day, so I think about whether I have been broadly happy, sad or somewhere in the middle.

I find it really interesting to see how things have been over a period of time, and also to think about what impacted on my mood. There are lots of things that influence our moods, so it can be very helpful to consider which of these we might be able to change.

If I have had lots of bad days, then I will look at my habit tracker and task lists, to assess what has affected me and what changes I might be able to make for the next month. Equally, if I have had lots of happy days, I look at what I can replicate in the following month, to ensure that this pattern continues as much as possible.

Mood trackers featuring every day of the month can be a lot of fun to create and I will be sharing some of my favourite illustrative ideas with you in this chapter.

Have a go at creating a washi tape mood tracker. Select a washi pattern for each mood that you want to record and then add a strip for each day of the month.

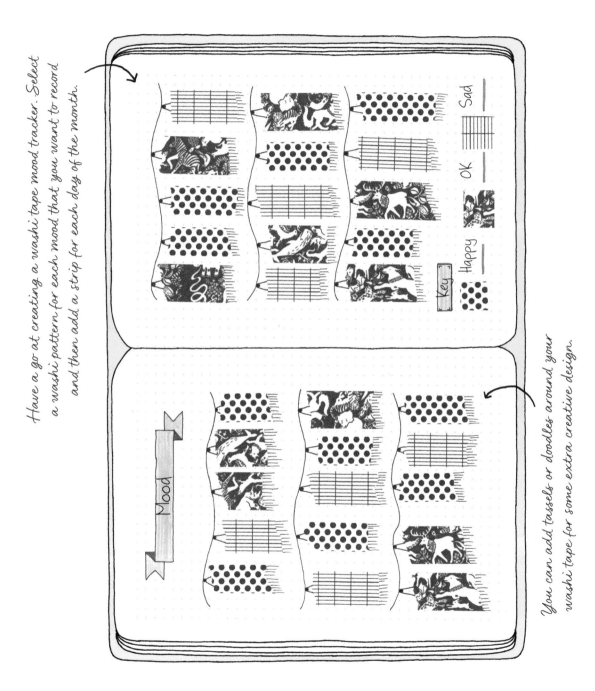

You can add tassels or doodles around your washi tape for some extra creative design.

Layout #12

For a fun and quirky mood tracker, try adding a doughnut doodle for each day of the month. You could of course pick other food items for this type of tracker.

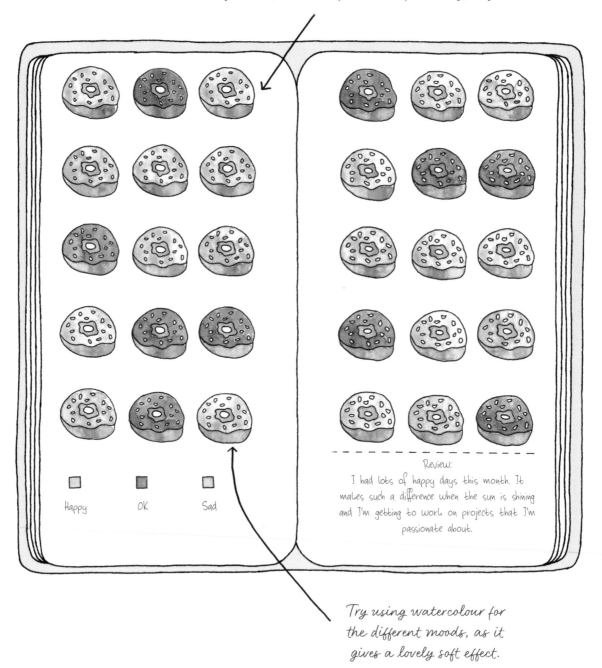

Happy OK Sad

Review:
I had lots of happy days this month. It makes such a difference when the sun is shining and I'm getting to work on projects that I'm passionate about.

Try using watercolour for the different moods, as it gives a lovely soft effect.

For this layout, draw some branches with leaves across the pages. Add different colours to the leaves each day to match your mood.

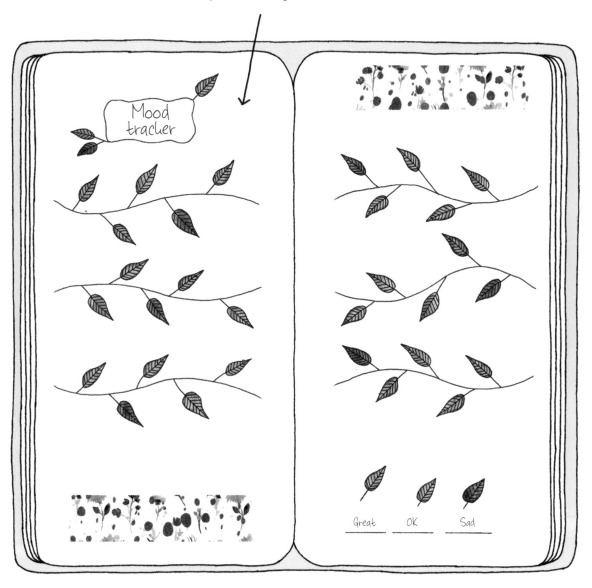

Mood tracker

Great OK Sad

If you want to track a morning and evening mood, you could add a pair of leaves for each day.

Layout #14

Create a circular mood tracker, using a compass. You could try matching the colours on your mood key to the illustration inside your circle.

Mood Tracker

28 29 30 1 2
27 3
26 4
25 5
24 6
23 7
22 8
21 9
20 10
19 11
18 17 16 15 14 13 12

Happy OK Bit low Sad

Felt good all day today – optimistic
Today was tough due to pressure of work
Lots of laughter so a great day
Tired so felt low today. Need an early night
Slept well and feeling more upbeat today
Received great feedback today – happy

Create a review page next to the mood tracker, using colours from the opposite page.

Floral bouquets can make great mood trackers and are a lovely visual representation of your month.

Layout #15

Trying creating a crystal mood tracker, ensuring that you have enough sections to colour one in every day.

Happy OK Sad

Happy
OK
Sad

WRITING PROMPTS

Alongside the mood trackers, it can be really beneficial to think about what is impacting on your mood and how you can use this knowledge to make improvements.

55. When were you last really happy?

56. What were you doing at the time?

57. What could you do to bring more of those happy moments into your life?

58. Which people in your life make you feel good?

59. What are the little things that make a big difference to how you feel?

60. Which things negatively impact on how you feel?

61. What can you do to limit those things, or at least limit the impact they have on you?

62. How good are you at moving on from something that has upset you?

63. What types of activity help to quickly put you in a good mood?

64. Are there any songs, books or TV shows that instantly make you feel happier?

65. What are some of your happiest memories?

66. What type of routine would help you to start your day in the most positive way?

67. What kinds of thing can you do to help you to unwind in the evening?

68. What do you need to stop doing to live a happier life?

69. How can you make more time in your life for the things that bring you joy?

70. Which things make you feel peaceful?

71. What was the best thing that happened today?

72. Is there any correlation between your habit tracker and mood tracker that you can learn from?

73. How long do any unhappy spells tend to last?

74. What goal could you focus on that will help to make you feel motivated and inspired?

75. When was the last time you treated yourself to something that makes you feel happy?

76. Plan a "date" with yourself and write it in your journal, filled with the types of activities that make you feel good.

77. How do you feel when surrounded by nature?

78. Do you have enough clutter-free space where you can relax?

79. Helping other people can make you feel really good. When was the last time you did something that made someone else smile?

80. How many activities do you have scheduled in that you know will make you happy?

81. Do you have a favourite positive quote that can instantly help to put a bad day into perspective?

Getting Organized

If you find that life can get a bit chaotic and you feel out of control, then your journal can be a great place to start getting on top of things. In this chapter we are going to look at future logs, where you can plan out your commitments, meetings, deadlines and tasks well in advance.

I also like to use my future logs to plan out my hopes and dreams. I find it really helpful to set deadlines for personal projects that I would love to work on, as it helps to keep me focused on what I would like to achieve, rather than just the things that are expected of me.

Having several months planned out ahead of time helps me to be realistic about what else I can fit in and also be aware of deadlines that are coming up. Of course, plans change over time and deadlines move, but having an outline in place is something I have found really beneficial. I always refer to my future log before taking on new work, as it gives me a feel as to whether I can realistically complete the work, or may need to move some of my other projects to accommodate it.

If you do not have work projects to focus on, you could still use these type of journal pages to plan out home projects, fitness goals, plans for your garden, travel or creative pieces that you want to work on.

Layout #16

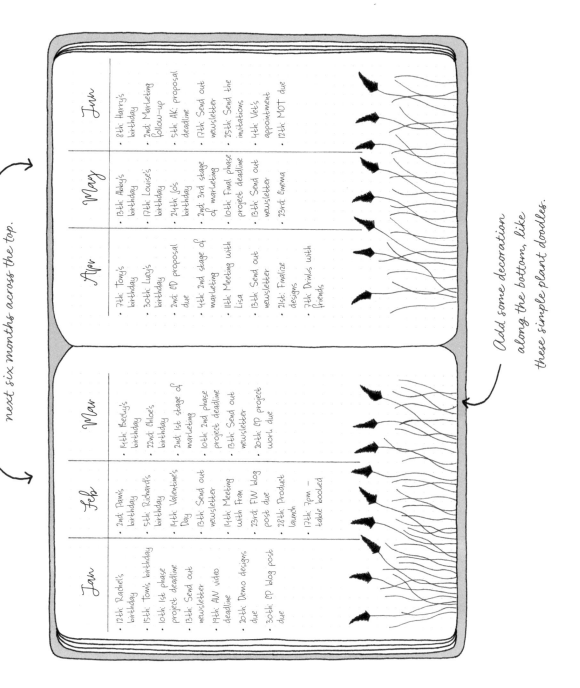

Divide your journal spread into six vertical sections and write the next six months across the top.

Jan
- 12th: Rachel's birthday
- 15th: Tom's birthday
- 10th: 1st phase project deadline
- 13th: Send out newsletter
- 19th: AW video deadline
- 20th: Demo designs due
- 30th: CP blog post due

Feb
- 2nd: Pam's birthday
- 5th: Richard's birthday
- 14th: Valentine's Day
- 13th: Send out newsletter
- 14th: Meeting with Fran
- 23rd: FW blog post due
- 28th: Product launch
- 17th: 7pm – table booked

Mar
- 14th: Becky's birthday
- 22nd: Chloe's birthday
- 2nd: 1st stage of marketing
- 10th: 2nd phase project deadline
- 13th: Send out newsletter
- 20th: CP project work due

Apr
- 7th: Tony's birthday
- 30th: Lucy's birthday
- 2nd: CD proposal due
- 4th: 2nd stage of marketing
- 11th: Meeting with Lisa
- 13th: Send out newsletter
- 21st: Finalize designs
- 7th: Drinks with friends

May
- 13th: Abby's birthday
- 17th: Louise's birthday
- 24th: Jo's birthday
- 2nd: 3rd stage of marketing
- 10th: Final phase project deadline
- 13th: Send out newsletter
- 23rd: Cinema

Jun
- 8th: Harry's birthday
- 2nd: Marketing follow-up
- 5th: AK: proposal deadline
- 17th: Send out newsletter
- 25th: Send the invitations
- 4th: Vet's appointment
- 12th: MOT due

Add some decoration along the bottom, like these simple plant doodles.

Layout #17

Cut out a piece of scrapbook or decorative paper for each month you would like to plan out.

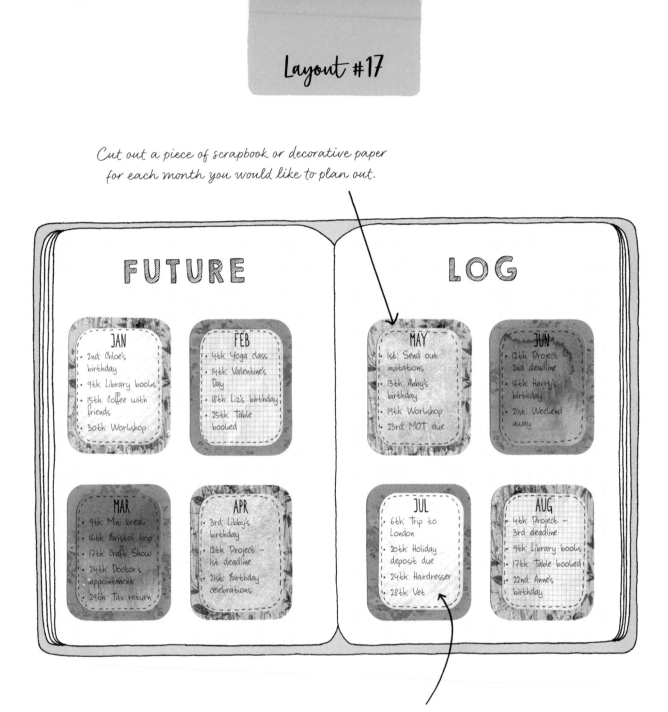

FUTURE LOG

JAN
- 2nd: Chloe's birthday
- 9th: Library books
- 15th: Coffee with friends
- 30th: Workshop

FEB
- 4th: Yoga class
- 14th: Valentine's Day
- 18th: Liz's birthday
- 25th: Table booked

MAR
- 9th: Mini break
- 16th: Bristol trip
- 17th: Craft Show
- 24th: Doctor's appointment
- 29th: Tax return

APR
- 3rd: Libby's birthday
- 12th: Project – 1st deadline
- 21st: Birthday celebrations

MAY
- 1st: Send out invitations
- 13th: Abby's birthday
- 19th: Workshop
- 23rd: MOT due

JUN
- 12th: Project – 2nd deadline
- 16th: Harry's birthday
- 21st: Weekend away

JUL
- 6th: Trip to London
- 20th: Holiday deposit due
- 24th: Hairdresser
- 28th: Vet

AUG
- 4th: Project – 3rd deadline
- 9th: Library books
- 17th: Table booked
- 22nd: Anne's birthday

Glue the papers to your journal pages and then add some less decorative paper on top to give you somewhere to write your plans for each month. You can add doodles or simple borders to each rectangle.

Layout #18

Mask off the areas that you want to use as text boxes, then use a stencil and ink to add colour to the rest of your spread.

JANUARY

Tasks
2nd: blog post
10th: Youtube video
15th: CK deadline

Birthdays
11th: Rachel
31st: Toby

FEBRUARY

Tasks
4th: ND deadline
8th: accountant
14th: RS meeting

Birthdays
2nd: Sarah
14th: Tom
20th: Alison

MARCH

Tasks
1st: blog post
5th: newsletter
11th: AM deadline

Birthdays
16th: Jeremy

APRIL

Tasks
7th: submit designs
8th: Youtube video
24th: sign-off

Birthdays
21st: Anne
30th: Rob

MAY

Tasks
3rd: blog post
12th: newsletter
17th: BK deadline

Birthdays
13th: Abby

JUNE

Tasks
2nd: Louise video
9th: Angie project
15th: Rachel meeting

Birthdays
5th: Hilary
19th: Tom
24th: Christine

Decorate the rest of the page with washi tape and stickers.

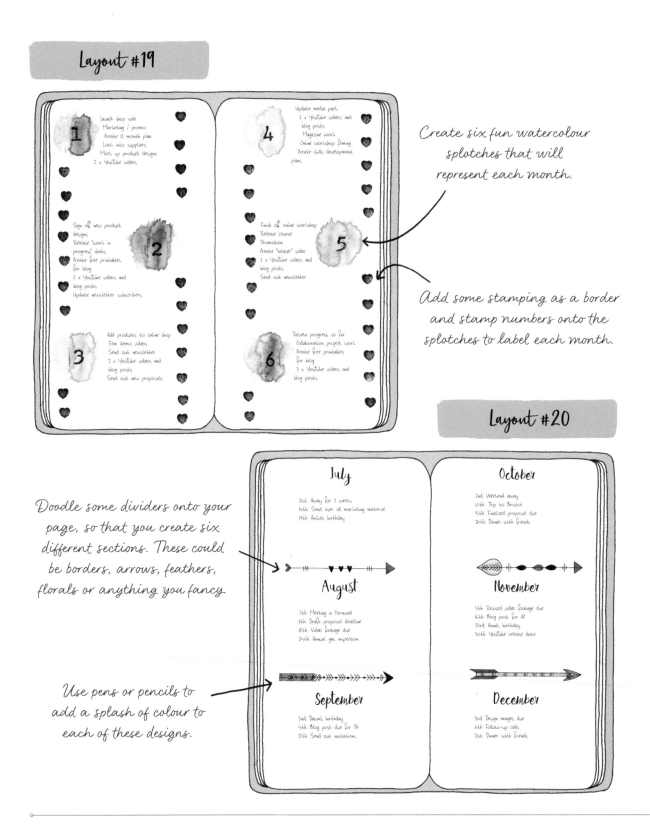

Layout #19

1
Launch shop sale
Marketing / promo
Create 12 month plan
Look into suppliers
Mock up product designs
2 x Youtube videos

2
Sign off new product designs
Release 'work in progress' shots
Create free printables for blog
2 x Youtube videos and blog posts
Update newsletter subscribers

3
Add products to online shop
Film demo videos
Send out newsletter
2 x Youtube videos and blog posts
Send out new proposals

4
Update media pack
2 x Youtube videos and blog posts
Magazine work
Online workshop filming
Create skills development plans

5
Finish off online workshop
Release course
Promotion
Create 'teaser' video
2 x Youtube videos and blog posts
Send out newsletter

6
Review progress so far
Collaboration project work
Create free printables for blog
3 x Youtube videos and blog posts

Create six fun watercolour splotches that will represent each month.

Add some stamping as a border and stamp numbers onto the splotches to label each month.

Layout #20

Doodle some dividers onto your page, so that you create six different sections. These could be borders, arrows, feathers, florals or anything you fancy

Use pens or pencils to add a splash of colour to each of these designs.

July
21st: Away for 2 weeks
14th: Send over all marketing material
19th: Anita's birthday

August
7th: Meeting in Cornwall
8th: Draft proposal deadline
18th: Video footage due
24th: Annual gas inspection

September
2nd: Dawn's birthday
4th: Blog post due for CH
12th: Send out invitations

October
2nd: Weekend away
10th: Trip to Bristol
15th: Finalized proposal due
20th: Dinner with friends

November
5th: Revised video footage due
16th: Blog post for AF
23rd: Annie's birthday
30th: Youtube release date

December
3rd: Design images due
6th: Follow-up calls
21st: Dinner with friends

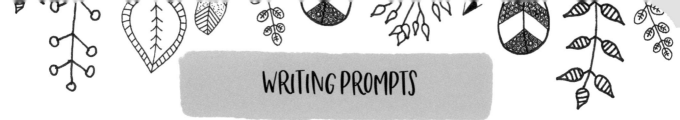

WRITING PROMPTS

Adding events, birthdays and deadlines to your future log is usually quite simple. However, I always think it is worth adding things that you really want to do for yourself. It is a wonderful feeling to look back over six or twelve months of your journal and see your own personal progress. I have included some prompts to get you thinking about what you might like to add to yours.

82. What would you most like to achieve over the next six months?

83. Is there a big project that you would really like to work on?

84. What tasks could you realistically add to each month to take you a little closer to your goals?

85. Do you have any personal challenges that you want to accomplish? Perhaps something related to fitness, learning or creativity?

86. If so, what can you plan out for the next few months to help with this?

87. What would a "successful" six months look like?

88. Are there any types of event or commitments that you tend to forget about until the last minute? If so, find out the dates and jot them down now.

89. Can you see any months where you are already over-committed?

90. Is there anything you could do to spread out these tasks or commitments?

91. Do you have a tendency to take on more responsibilities than you really have time for?

92. Try using your future log to be a little kinder to yourself, so that you do not take on more than is comfortable for you.

93. Have you scheduled any "down-time" in your future log?

94. What fun activities could you commit to, that would help you to enjoy a more balanced life?

95. Do you have any financial goals that you could include in your future log? This could include savings goals or paying off debt.

96. Do you have friends or family that you have not seen in too long? Add a date to your future log to make sure you commit to meeting up.

97. Is there anything you have been putting off that is starting to weigh you down? Set a date to get it done. You will thank yourself later.

98. Which things are truly in your control?

99. What type of commitments should you be turning down to enable you to focus on the most important things to you?

100. Do you have any learning goals or milestones you could record in your plans?

101. Do your plans reflect the things you really want to be working on?

102. What are you making more difficult for yourself than it needs to be?

103. How happy do your future commitments make you feel?

104. What small changes could you make to your schedule that would improve your quality of life?

105. Do you think you are busier than other people?

106. Why is this and are you happy about that?

107. Who is your role model and what can you learn from their schedule?

108. Are you in control of your schedule? Or have outside commitments determined it for you?

A New Chapter

Including a monthly cover page in your journal is a great way to set a theme for the month ahead. I always like to think of a month as being a new chapter, where you get to review how things have been going and revise your plans to keep on track.

A monthly cover page does not have to provide a functional purpose, though it certainly can if you like. For me, it is a lovely way to get creative and reflect on the season or perhaps events that will be going on for me that month.

In this chapter, I will be sharing some of my favourite ways to create a cover page, which I hope gives you some ideas for your journal. It is the perfect space to have fun and try out new techniques.

Layout #21

Use a compass to create a circle in pencil, or you could draw around a bowl. Then start doodling seasonal floral elements, leaves and branches that roughly follow the shape of the circle.

April showers Bring May flowers

May

Add some of the designs from the opposite page to create a matching quote page for the month.

Ink in your design, erase the pencil and add colour using pencils, pens or watercolour.

Cut out a circle and use washi tape to stick it
down on your page as a mask. Use a stencil and
ink pads to create a pattern over both pages.

GOALS FOR THE MONTH

- Submit new proposals
- Finish magazine commission
- Take an online class
- Empty out spare room
- Complete creative project
- Take stuff to charity shop
- Follow-up with clients

August

Remove the paper circle, which leaves
you space to letter out the month. Finish
off by adding any extra decoration with
stickers, washi tape or stamping.

Add some stamping and colour to both pages.

Write out the name of the month vertically down the left-hand page. Try and come up with some sentences for the month that begin with each letter you have written.

Create a simple collage using old book pages, tickets and washi tape.

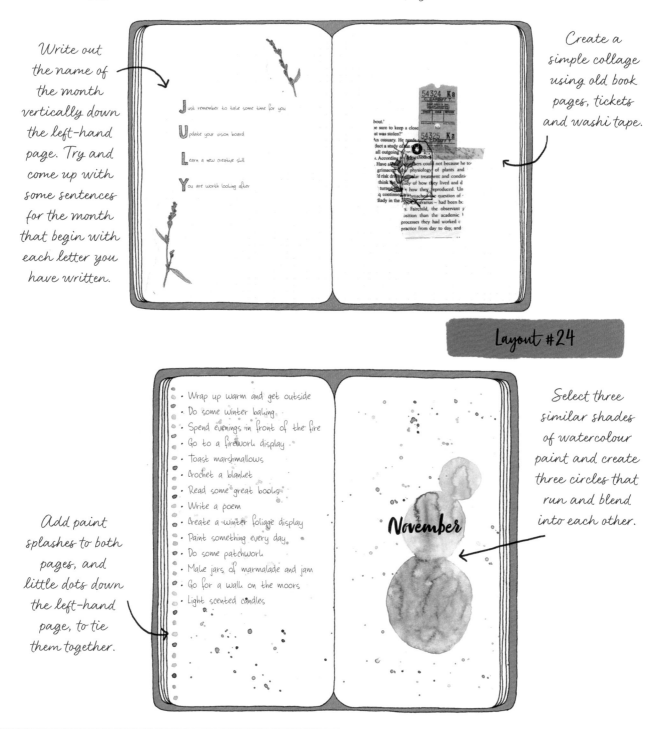

J ust remember to take some time for you

U pdate your vision board

L earn a new creative skill

Y ou are worth looking after

Layout #24

Select three similar shades of watercolour paint and create three circles that run and blend into each other.

Add paint splashes to both pages, and little dots down the left-hand page, to tie them together.

- Wrap up warm and get outside
- Do some winter baking
- Spend evenings in front of the fire
- Go to a firework display
- Toast marshmallows
- Crochet a blanket
- Read some great books
- Write a poem
- Create a winter foliage display
- Paint something every day
- Do some patchwork
- Make jars of marmalade and jam
- Go for a walk on the moors
- Light scented candles

November

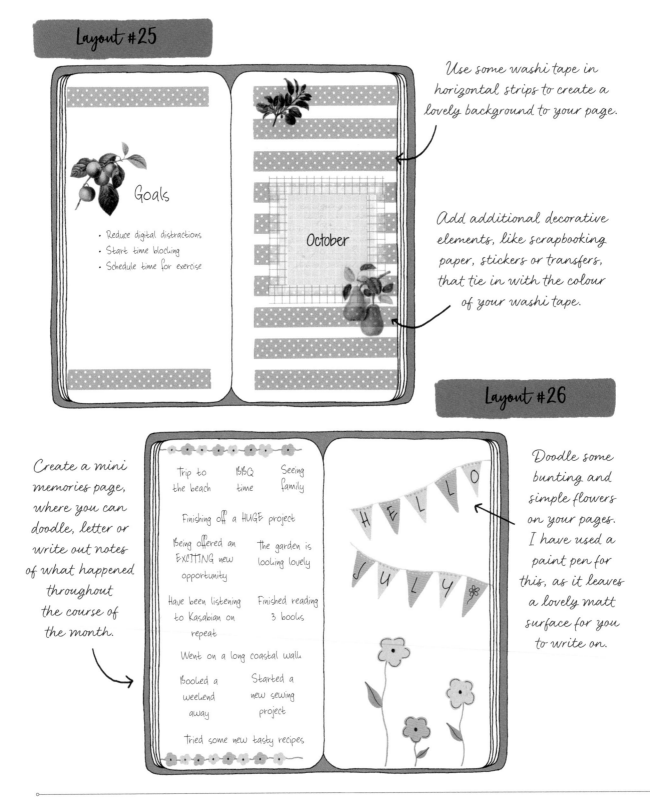

Layout #25

Use some washi tape in horizontal strips to create a lovely background to your page.

Goals

- Reduce digital distractions
- Start time blocking
- Schedule time for exercise

October

Add additional decorative elements, like scrapbooking paper, stickers or transfers, that tie in with the colour of your washi tape.

Layout #26

Create a mini memories page, where you can doodle, letter or write out notes of what happened throughout the course of the month.

Trip to the beach BBQ time Seeing family

Finishing off a HUGE project

Being offered an EXCITING new opportunity

The garden is looking lovely

Have been listening to Kasabian on repeat

Finished reading 3 books

Went on a long coastal walk

Booked a weekend away

Started a new sewing project

Tried some new tasty recipes

HELLO JULY

Doodle some bunting and simple flowers on your pages. I have used a paint pen for this, as it leaves a lovely matt surface for you to write on.

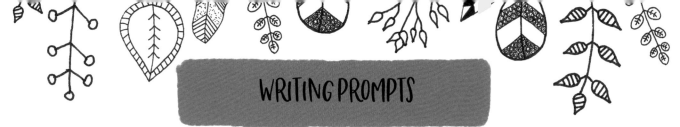

WRITING PROMPTS

Before creating your monthly cover page, it is a good idea to think about what you want it to represent to you every time you open your journal. Have a think about the prompts below and see if they spark any ideas.

109. Find some great quotes, mantras or lyrics that make you feel inspired and ready to face the month ahead.

110. What is your overriding intention for the month?

111. Do you have any goals that you would like to achieve next month?

112. Can you think of a "bucket list" of fun activities that you would like to do this month? This could include things like places you want to visit, books you want to read or new recipes that you fancy trying out.

113. What does this month mean to you?

114. Could you represent this on your cover page?

115. What things of note have happened during the past month?

116. Use some space on your cover page to write about events from your own life or that you heard or read about in the news that have occurred throughout the month.

117. Which flowers are in bloom this month?

118. What colours represent this month to you?

119. What themes are starting to emerge on social media or the news?

120. What is your favourite aspect of nature at this time of year?

121. What were you doing this time last year?

122. In what way do you want the new month to feel different to last month?

123. What subtle changes are you noticing outside?

124. What images reflect this time of year?

125. Can you think of a word or sentence beginning with each letter of the month, that reflect this particular period?

126. What is currently "trending"?

127. What type of foods are typically eaten at this time of year?

128. Where will you be spending most of this month?

129. What is your favourite thing about this particular time of year?

130. What type of clothes do you most enjoy wearing at the moment?

131. Which hobbies are you most likely to be doing?

132. If you Google this month, what images come up?

133. What song is currently played everywhere?

134. Which movies or TV shows are the ones to watch right now?

The Month Ahead

I really enjoy having a monthly calendar and overview page in my journal. While I do use an electronic calendar alongside my journal, the process of writing these commitments and events down helps me to stay aware of what is coming up.

Before the new month begins, I jot down all of the events and deadlines that I have already committed to. I can then add anything new as it crops up to make sure that everything is recorded.

Another benefit for me is that I can write down a quick note of anything I have been working on that day, such as catching up on admin, submitting proposals or dealing with telephone calls. This means that by the end of the month I have a really clear overview of how I spent my time, which I can learn from for the next month.

With a digital calendar, I just do not use it in the same way, somehow, or ever look back through it to see where my time has gone. Having everything in a journal encourages that self-reflection and learning, in a way that really suits how my mind works.

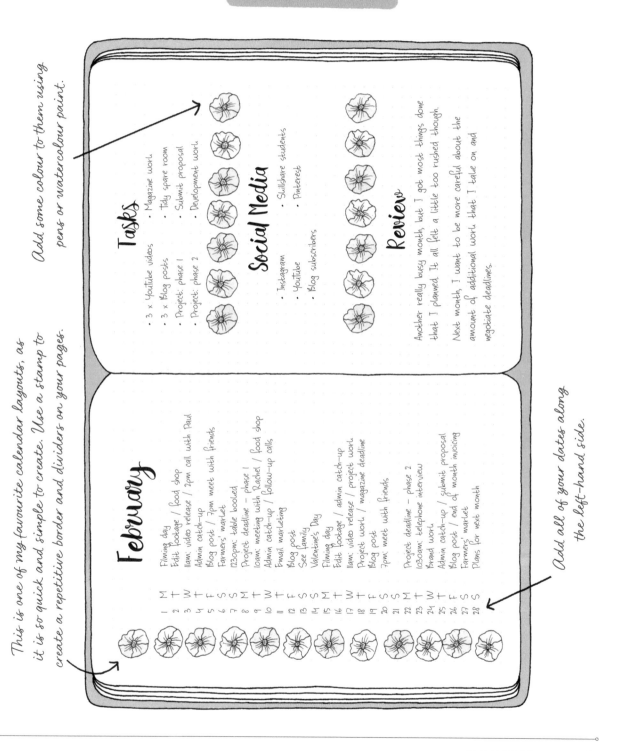

Layout #27

This is one of my favourite calendar layouts, as it is so quick and simple to create. Use a stamp to create a repetitive border and dividers on your pages.

Add some colour to them using pens or watercolour paint.

Tasks

- 3 x Youtube videos
- 3 x Blog posts
- Project: phase 1
- Project: phase 2
- Magazine work
- Tidy spare room
- Submit proposal
- Development work

Social Media

- Instagram
- Youtube
- Blog subscribers
- Sullshare students
- Pinterest

Review

Another really busy month, but I got most things done that I planned. It all felt a little too rushed though.

Next month, I want to be more careful about the amount of additional work that I take on and negotiate deadlines.

February

1	M	Filming day
2	T	Edit footage / food shop
3	W	11am: video release / 2pm call with Paul
4	T	Admin catch-up
5	F	Blog post / 7pm meet with friends
6	S	Farmers' market
7	S	12:30pm: table booked
8	M	Project deadline – phase 1
9	T	10am: meeting with Rachel / food shop
10	W	Admin catch-up / follow-up calls
11	T	Email marketing
12	F	Blog post
13	S	See family
14	S	Valentine's Day
15	M	Filming day
16	T	Edit footage / admin catch-up
17	W	11am: video release / project work
18	T	Project work / magazine deadline
19	F	Blog post
20	S	7pm: meet with friends
21	S	
22	M	Project deadline – phase 2
23	T	10:30am: telephone interview
24	W	Brand work
25	T	Admin catch-up / submit proposal
26	F	Blog post / end of month invoicing
27	S	Farmers' market
28	S	Plans for next month

Add all of your dates along the left-hand side.

Layout #28

Draw out a box calendar across both pages. My boxes are six dots wide by six dots tall.

Pick a theme and add some doodles. I thought that summer holiday doodles would be a great match for July.

JULY

Mon	Tues	Weds	Thurs
		Filming	Release video
			2
Admin	Filming Food shop	Release video	9am: MOT
6	7	8	9
Send email follow-ups	Food shop	Admin	Submit proposal
13	14	15	16
Admin	Food shop	10am: meeting with Jo	
20	21	22	23
	Food shop	Admin	Project work
27	28	29	30

Fri	Sat	Sun
Blog post	Garden centre	Sunday lunch
3	4	5
10am: call with Richard	7pm: dinner with friends	Country walk
10	11	12
Blog post	Go to antiques + shops	Gardening
17	18	19
1pm: livestream	Farmers' market	1pm: table booked
24	25	26
Invoicing Blog post		
31		

You can draw additional doodles in the boxes that you will not need.

Turn your journal around and try fitting a box calendar on one page. Each of my boxes are five dots squared. This works really well if you only have a few commitments each day.

Pick a colour scheme and decorate using pens, stickers and washi tape.

September

MONDAY	TUESDAY	WEDNESDAY	THURSDAY	FRIDAY	SATURDAY	SUNDAY
	Filming 1	Video release 2	Project work 3	Blog post 4	Antiques fair 5	6
Admin 7	Filming 8	Video release 9	Project work 10	Blog post 11	12	Car boot sale 13
14	Filming 15	Video release 16	Project work 17	Blog post 18	19	Weekend away 20
Admin 21	Filming 22	Video release 23	Project deadline 24	Blog post 25	7pm meet friends 26	27
J's birthday 28	Filming 29	Video release 30				

OVERVIEW

A really good month and lovely to have a weekend away. I'm feeling on top of things at last and ready for October

NEXT MONTH

- Finish marketing plan
- Send follow-up emails
- AM project work
- Proposals follow-up

TASKS

- AK proposals
- NL proposals
- Marketing plans
- 4 x blog posts
- Complete FR project
- 4 x Youtube videos
- Filing
- Tidy up garden
- Follow-up emails
- Buy birthday present
- Project work
- Buy new plants
- Book weekend away

Create some separate boxes for your main tasks for the month, an overview and anything that is coming up over the following month. You could of course use these boxes in a different way if you prefer.

Layout #30

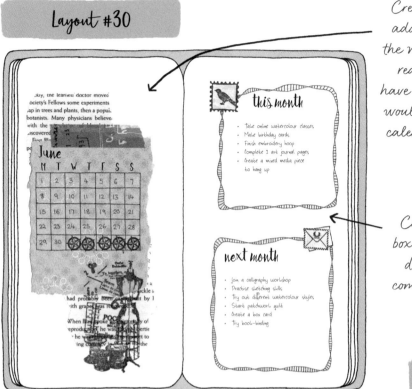

Create a collage and then add a simple calendar for the month on top. This works really well if you do not have many commitments, but would still like to include a calendar for quick reference.

Create two doodle-style boxes where you can write down anything that is coming up over the month.

Layout #31

See if you can find some patterned paper that is big enough to use as a background for your page. For this vibrant spread, I used patterned paper that came free with a magazine.

Glue some paper on top onto which you can write down your goals for the month.

On the opposite page, use pens in matching colours to draw out boxes for your calendar. I used three alternating colours.

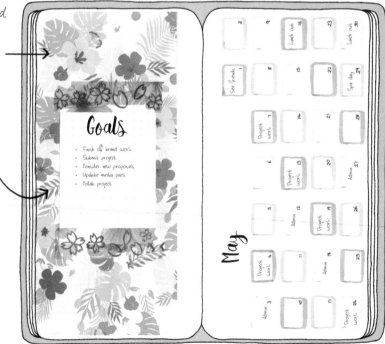

WRITING PROMPTS

When setting out your plans for the month ahead, it is beneficial to think about how you want things to go. This gives you a chance to adjust your plans and make sure you have scheduled in activities that are important to you. Try answering some of the prompts below to help with this.

135. What would a great month look like to you?

136. What is your most important priority this month?

137. What are your top three goals for the month?

138. Is there anything that you need some help with this month?

139. Can you think of someone who could support you with this?

140. Is there anything you can learn from last month, that you want to improve on?

141. Is there something that went really well last month, that you can replicate?

142. Does the month look balanced to you, or do you need to fit in some more time for fun activities?

143. Do you have any gaps in your calendar that you could use to focus on a really exciting project?

144. If so, what is the main thing you would particularly like to make progress on?

145. How do you feel about the workload that you are taking on this month?

146. Is there anything you could do to reduce it?

147. Have you spent time understanding where your time went last month?

148. Do you need to block out any time to enable you to focus on a key task or project?

149. What could you do to reduce distractions during that period?

150. Do you have anything coming up this month that you are dreading?

151. What could you do to help to prepare for this?

152. What tasks are likely to make you procrastinate?

153. Could you tackle them first to get them out of the way?

154. What are you most excited about that you have planned for this month?

155. How are your energy levels at the moment?

156. What could you schedule in that would help to give them a boost?

157. What events are happening this month that are a "must" for you?

158. Have you left enough gaps in your schedule to cope with the unexpected?

159. What progress have you made since this time last year?

160. What did you do to achieve this?

161. What positive impact can you make on others this month?

The Week Ahead

The weekly planning spreads that I create in my journal are some of my most helpful pages. Every weekend I set up the pages for the following week and note down everything that I hope to get done. It helps to keep me organized and focused, rather than just rushing from one day to the next.

I also use my weekly pages to record deadlines, note down the food I have eaten and also for a mini habit tracker. At the end of the week I review everything as a whole, rather than just the tasks I have completed. It is interesting to note how a busy workload can lead to eating unhealthy food or lack of exercise, so I always think there is a lot to learn from these types of journal pages.

I also like to leave some space where I can record things that need to be done the following week, so that if I do have any spare time I can use that to get ahead a little.

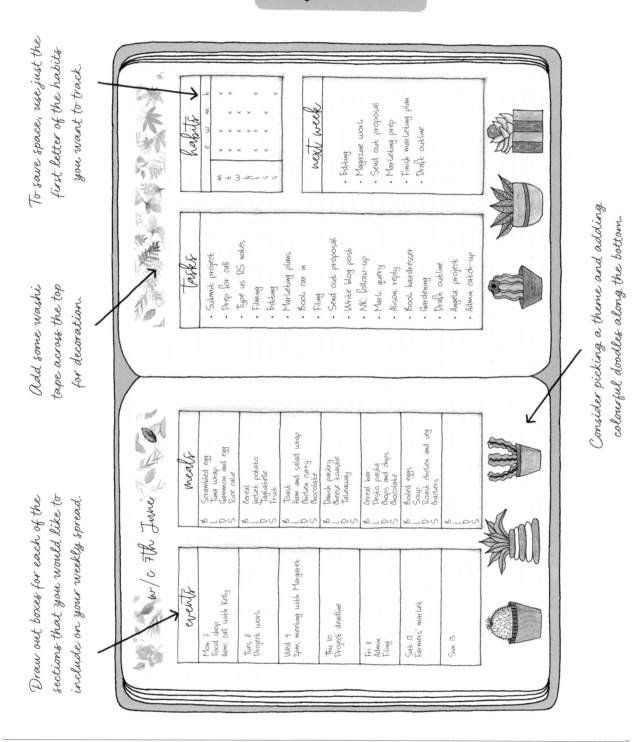

To save space, use just the first letter of the habits you want to track.

Add some washi tape across the top for decoration.

Draw out boxes for each of the sections that you would like to include on your weekly spread.

Consider picking a theme and adding colourful doodles along the bottom.

habits

	m	t	w	t	f	s	s
e	×	×	×		×		×
w	×	×	×	×	×		×
m	×	×	×	×	×		×
h	×	×	×		×		×

next week
- Editing
- Magazine work
- Send out proposal
- Marketing prep
- Finish marketing plan
- Draft outline

tasks
- Submit project
- Prep for call
- Type us RS notes
- Filming
- Editing
- Marketing plans
- Book car in
- Filing
- Send out proposal
- Write blog post
- NK follow-up
- Marc query
- Alison reply
- Book hairdresser
- Gardening
- Draft outline
- Angela project
- Admin catch-up

w/c 7th June

meals

B	Scrambled egg
L	Tuna wrap
D	Gammon and egg
S	Rice cake
B	Cereal
L	Jacket potato
D	Tagliatelle
S	Fruit
B	Toast
L	Ham and salad wrap
D	Chicken curry
S	Chocolate
B	Danish pastry
L	Cheese toastie
D	Takeaway
S	
B	Cereal bar
L	Pesto pasta
D	Chops and chips
S	Chocolate
B	Boiled eggs
L	Soup
D	Roast chicken and veg
S	Crackers
B	
L	
D	
S	

events

Mon 7
Food shop
11am: call with Kelly

Tues 8
Project work

Wed 9
2pm: meeting with Margaret

Thu 10
Project deadline

Fri 11
Admin
Filing

Sat 12
Farmers' market

Sun 13

Layout #33

If you have fewer tasks that need to get done, you might
find a simpler layout more appropriate. Draw out
four boxes, or as many as are right for your needs.

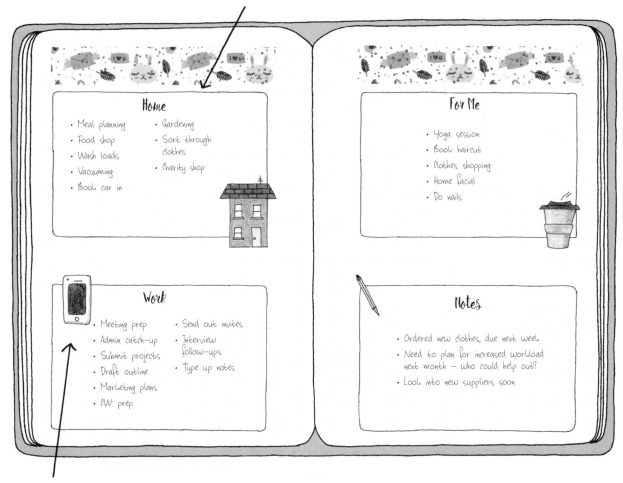

Home
- Meal planning
- Food shop
- Wash loads
- Vacuuming
- Book car in
- Gardening
- Sort through clothes
- Charity shop

For Me
- Yoga session
- Book haircut
- Clothes shopping
- Home facial
- Do nails

Work
- Meeting prep
- Admin catch-up
- Submit projects
- Draft outline
- Marketing plans
- CW: prep
- Send out invites
- Interview follow-ups
- Type up notes

Notes
- Ordered new clothes, due next week
- Need to plan for increased workload next month – who could help out?
- Look into new suppliers soon

Add a doodle for
each section.

Layout #34

For this fun layout, cut out pieces of paper the size of boxes or circles that you wish to leave blank for text. Use some washi tape to temporarily stick them to your page to mask these areas.

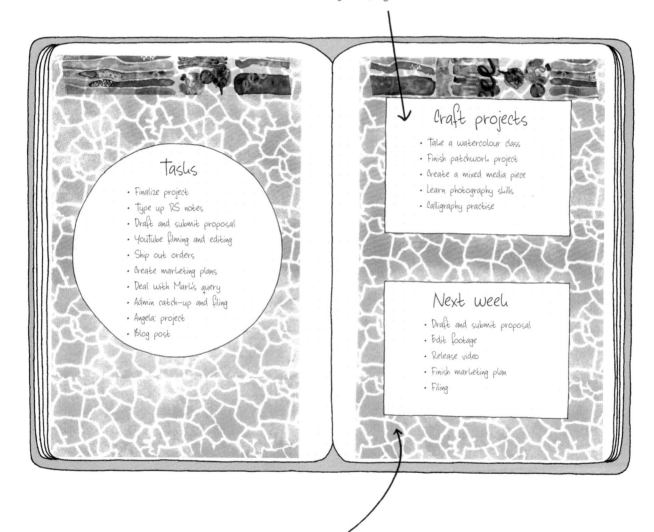

Tasks

- Finalize project
- Type up RS notes
- Draft and submit proposal
- Youtube filming and editing
- Ship out orders
- Create marketing plans
- Deal with Mark's query
- Admin catch-up and filing
- Angela: project
- Blog post

Craft projects

- Take a watercolour class
- Finish patchwork project
- Create a mixed media piece
- Learn photography skills
- Calligraphy practise

Next week

- Draft and submit proposal
- Edit footage
- Release video
- Finish marketing plan
- Filing

Use a stencil and ink pads to create a pattern all over both pages, then remove the pieces of paper.

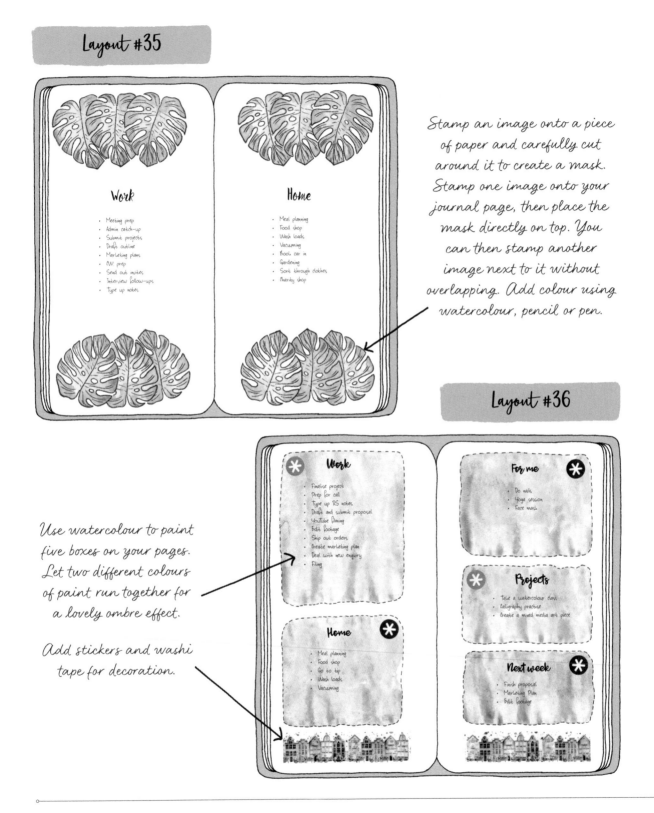

Layout #35

Work

- Meeting prep
- Admin catch-up
- Submit projects
- Draft outline
- Marketing plans
- CW prep
- Send out invites
- Interview follow-ups
- Type up notes

Home

- Meal planning
- Food shop
- Wash loads
- Vacuuming
- Book car in
- Gardening
- Sort through clothes
- Charity shop

Stamp an image onto a piece of paper and carefully cut around it to create a mask. Stamp one image onto your journal page, then place the mask directly on top. You can then stamp another image next to it without overlapping. Add colour using watercolour, pencil or pen.

Layout #36

Use watercolour to paint five boxes on your pages. Let two different colours of paint run together for a lovely ombre effect.

Add stickers and washi tape for decoration.

Work

- Finalise project
- Prep for call
- Type up RS notes
- Draft and submit proposal
- Youtube filming
- Edit footage
- Ship out orders
- Create marketing plan
- Deal with new enquiry
- Filing

Home

- Meal planning
- Food shop
- Go to tip
- Wash loads
- Vacuuming

For me

- Do nails
- Yoga session
- Face mask

Projects

- Take a watercolour class
- Calligraphy practise
- Create a mixed media art piece

Next week

- Finish proposal
- Marketing Plan
- Edit footage

WRITING PROMPTS

In the same way that it is beneficial to carefully plan out your month, it is equally important to do the same before a new week. Try spending some time before the week begins, to make sure you are focusing on all of the right things. Use the prompts below to help with your planning.

162. What is your top priority for this week?

163. If you were to pick three goals for the week, what would they be?

164. Are there any projects that you could make a start on?

165. Is there anything that you did not get done last week that really deserves your attention?

166. What meal planning could you do now, to help the week to run more smoothly?

167. Are there any habits that you would like to really focus on this week?

168. If so, how are you going to plan them in?

169. Are there any personal projects that you would like to spend more time on?

170. If so, can you find some time in your weekly schedule that you could block out for this?

171. Do you have any deadlines coming up that you could start working towards now?

172. Is there a big project that you have been putting off for a while now?

173. If so, what is the first small step that you need to take to get started?

174. How many fun activities do you have planned for this week?

175. Have you scheduled in sufficient time to relax and unwind?

176. Do you work best with a formal schedule, or do you prefer to see where things take you?

177. What does a successful week look like to you?

178. Do you prefer variety in your work, or just focusing on one particular type of task?

179. What kind of work shows you at your best?

180. How often to you get the opportunity to do this kind of work?

At the end of the week, consider the following:

181. How do you feel your week went?

182. What have you learnt that could make next week run more smoothly?

183. Do you consider this a week well spent?

184. What impact have the last few days had on your energy levels?

185. What steps have you taken to regroup and recharge your batteries?

186. What is the biggest lesson you learnt this week?

187. What was the best thing about this week?

Daily Planning

I use my journal to write down my tasks for each day, to help me to stay on top of things that need to be done. I always create the list in the evening so that when I wake up the next day, I already know my main priorities and what I will be working on. I may well have to add to this list throughout the day, following emails and telephone calls, but I always try to keep my original plan in mind.

I think it is really important to maintain focus on your own priorities while dealing with other tasks that come up. It is all too easy to be swept along by other people's requests, at the cost of things that are important to you.

As with any type of planning, you could of course use digital tools, but there is something very powerful about committing your intentions to paper. It helps to make you more focused and aware, plus there is something ever so satisfying about being able to physically mark those tasks as complete.

I keep my journal open on my desk all day to ensure that I can easily see what needs doing and re-prioritize quickly if urgent tasks arise. Since I started using a journal to plan out my work and home life, I have become much more productive and, more importantly, spend far more time working on areas that are really important to me.

I like to get creative in my journal, as visually appealing pages encourage me to use them every day. There are lots of quick and easy ways to get creative, or you can really take your time to improve your artistic skills while planning out your days.

Divide your journal pages into columns. You can create six columns if you tend to have less to do at the weekend, or seven if you prefer.

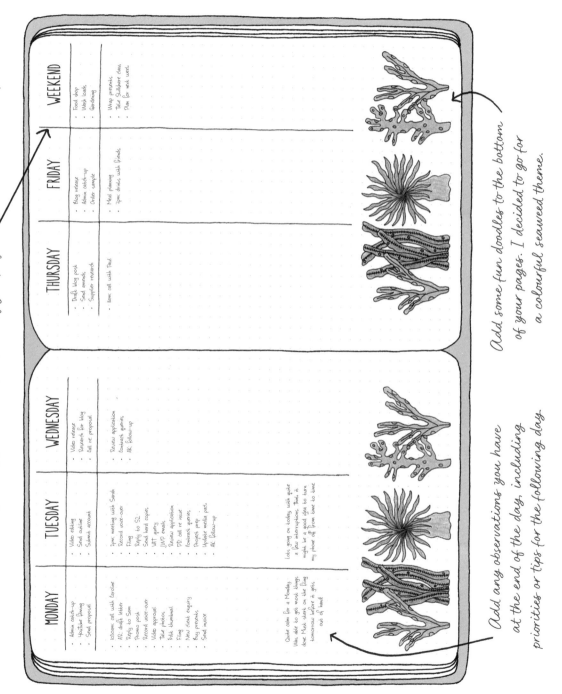

Add some fun doodles to the bottom of your pages. I decided to go for a colourful seaweed theme.

Add any observations you have at the end of the day, including priorities or tips for the following day

MONDAY
- Admin catch-up
- YouTube filming
- Send proposal

- 12:00am call with Caroline
- AR: draft letter
- Reply to Sam
- Promo post
- Record voice-over
- Video approval
- Edit thumbnail
- Filing
- New client enquiry
- Buy presents
- Send invoice

Quite calm for a Monday. Was able to get most things done. Must start on what thing tomorrow before it gets out of hand.

TUESDAY
- Video editing
- Send outline
- Submit accounts

- 7pm meeting with Sarah
- Record voice-over
- Filing
- Reply to S2
- Send hard copies
- VAT query
- UVD emails
- Review application
- PD call re issue
- Bookmark queries
- Projects prep
- Update media post
- AK follow-up

Lots going on today, with quite a few interruptions. Think it might be a good idea to turn my phone off from time to time

WEDNESDAY
- Video release
- Research for blog
- Call re proposal

- Review application
- Bookmark queries
- AK follow-up

THURSDAY
- Draft vlog post
- Send awards
- Supplier research

- 11am call with Paul

FRIDAY
- Blog release
- Admin catch-up
- Order sample

- Meal planning
- 7pm drinks with friends

WEEKEND
- Food shop
- Wash loads
- Gardening

- Wrap presents
- Take SueWare class
- Plan for work week

Layout #38

Add a length of decorative washi tape to the outer edge of the right-hand page.

Monday
- Admin catch-up
- Youtube filming
- AR: letter
- Video approval

Tuesday
- Send proposal
- Call with Caroline
- Promo post
- Record voice-over
- Photos

- Edit thumbnail
- Filing
- Contract queries
- New client enquiry
- Buy presents
- Send invoice

- Filing
- Send invoice
- VAT query
- P: call

Wednesday
- JWP emails
- Review application
- Contract queries
- AK: follow-up

Thursday
- JWP emails
- Change profile
- Call re: proposal

- Update RD
- Video release
- Research for blog

Friday

Saturday

Sunday

Use this washi tape for inspiration and create matching doodles. Washi tape can provide great ideas if you are having a creative block. Pick out small elements, or even just the colours, to create cohesive looking pages.

Draw out boxes on your page in pencil and add doodles in the bottom corners of some.

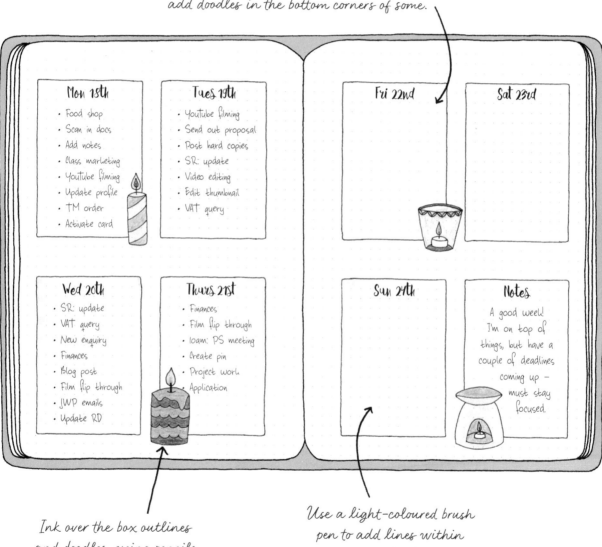

Mon 18th
- Food shop
- Scan in docs
- Add notes
- Class marketing
- Youtube filming
- Update profile
- TM order
- Activate card

Tues 19th
- Youtube filming
- Send out proposal
- Post hard copies
- SR: update
- Video editing
- Edit thumbnail
- VAT query

Fri 22nd

Sat 23rd

Wed 20th
- SR: update
- VAT query
- New enquiry
- Finances
- Blog post
- Film flip through
- JWP emails
- Update RD

Thurs 21st
- Finances
- Film flip through
- 10am: PS meeting
- Create pin
- Project work
- Application

Sun 24th

Notes
A good week! I'm on top of things, but have a couple of deadlines coming up — must stay focused.

Ink over the box outlines and doodles, using pencils or pens to add colour.

Use a light-coloured brush pen to add lines within some of the boxes.

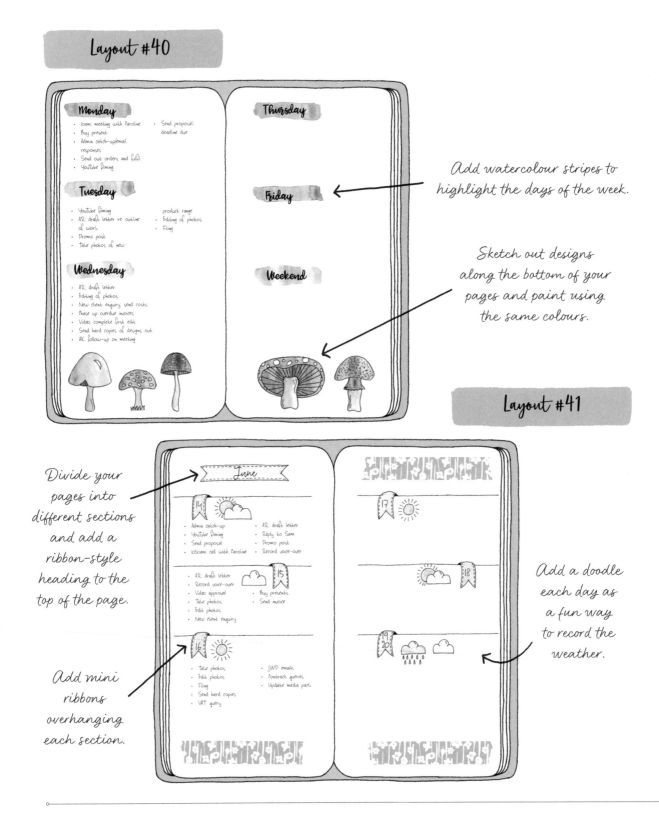

Layout #40

Monday
- loam meeting with Caroline
- Buy present
- Admin catch-up/email responses
- Send out orders and fulfil
- Youtube filming
- Send proposal deadline due

Tuesday
- Youtube filming
- AR draft letter re outline of work
- Promo post
- Take photos of new
- product range
- Editing of photos
- Filing

Wednesday
- AR draft letter
- Editing of photos
- New client enquiry, send costs
- Chase up overdue invoices
- Video complete first edit
- Send hard copies of designs out
- AK follow-up on meeting

Thursday

Friday

Weekend

Add watercolour stripes to highlight the days of the week.

Sketch out designs along the bottom of your pages and paint using the same colours.

Layout #41

Divide your pages into different sections and add a ribbon-style heading to the top of the page.

June

14
- Admin catch-up
- Youtube filming
- Send proposal
- 1030am call with Caroline
- AR draft letter
- Reply to Sam
- Promo post
- Record voice-over

15
- AR draft letter
- Record voice-over
- Video approval
- Take photos
- Edit photos
- New client enquiry
- Buy presents
- Send invoice

16
- Take photos
- Edit photos
- Filing
- Send hard copies
- VAT query
- JWD emails
- Contract queries
- Update media pack

17

18

19 20

Add mini ribbons overhanging each section.

Add a doodle each day as a fun way to record the weather.

WRITING PROMPTS

Getting a good daily planning system in place can do wonders for your productivity and happiness. Have a think about the prompts below to see if they could help you to create the ideal daily plan.

188. What are your top three priorities for today?

189. What else would you like to get done?

190. At what times of day are you most productive?

191. Can you arrange your work-flow to suit the times when you have the most energy?

192. Are you good at saying "no" when people try to give you too much extra work at short notice?

193. Would it help you to divide your tasks into "must do" / "would like to do" / "only if time allows"?

194. How do you feel when your day goes to plan?

195. What steps could you take to help more days go like that?

196. Are there any tasks you could batch together to make you more productive?

197. Would it help you to get your least enjoyable task out of the way first?

198. Is there anything on your list that someone else could help you with?

199. Are there tasks that would be easier to focus on if you turned off your electronic notifications?

200. What times do you plan to start work and switch off for the day?

201. Have you built in enough periods of rest throughout the day?

202. Have you scheduled in any self-care activities?

203. How long do tasks actually take you, compared to how long you think they will?

204. What can you learn from this?

205. Are you often planning in too many tasks for each day, making you feel overwhelmed?

206. Does your plan for the day make you feel good?

207. How many tasks on your list are things that are personally important to you?

At the end of each day, spend a few moments considering the following:

208. What was the most valuable task that you completed today?

209. What is the first thing you will do tomorrow?

210. Do you consider this a day well spent?

211. Was today focused on things you wanted to do, or things you had to do?

212. How are you feeling about tomorrow's plans?

213. What was the most important thing you accomplished today?

Reflective Journaling

I find that reflective journaling is a really powerful tool to help you to quieten your mind, gain a fresh perspective and deal with emotions or worries. I like to start this journaling practice by getting creative and putting something down on my page. For me, the creative side is the signal to my mind that I am about to slow down and pay attention. While I am adding the creative elements, I start to think about what I want to use this journaling session for, and it helps my mind to switch off from the distractions around me.

Sometimes I use this journal for ponderings about life in general. On other occasions, I like to really delve into something that has been on my mind. I always feel so much better after getting my thoughts onto paper.

I often find that I sit down feeling worried about something, but by the time I have completed my journal writing, I have a much more positive outlook and some ideas for how I can deal with a difficult situation. I think that we often already have the answers to our own worries, but it can be hard to take the time we need to relax, be quiet and listen to our thoughts while letting our ideas develop.

A journal can be a great place to celebrate life's victories, learn from our mistakes and ultimately make us happier, more well-balanced people. I love looking back through my journal entries, to see how I have coped with previous situations and recognize how far I have come. There is no correct way to use a journal, but if after writing you feel more relaxed and like your mind has been freed up a little, then I think you are on the right path.

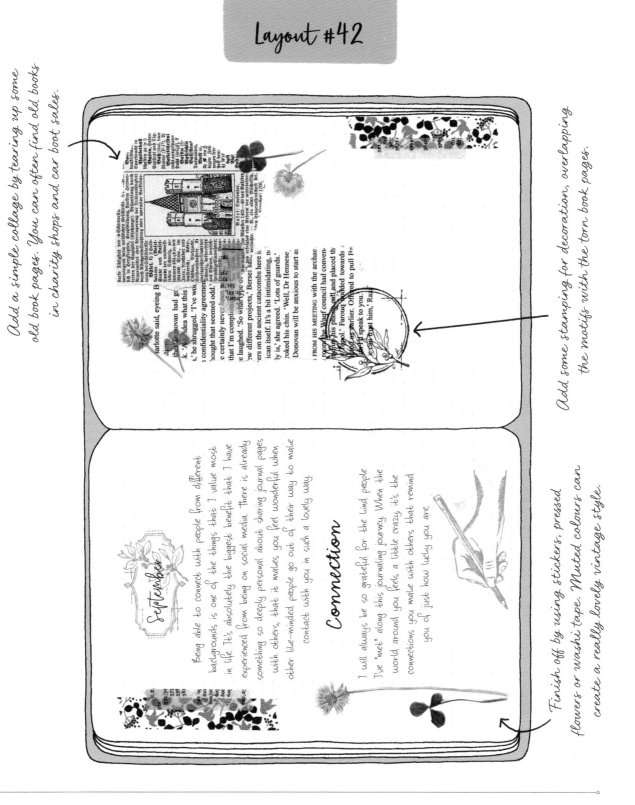

Add a simple collage by tearing up some old book pages. You can often find old books in charity shops and car boot sales.

Add some stamping for decoration, overlapping the motifs with the torn book pages.

September

Being able to connect with people from different backgrounds is one of the things that I value most in life. It's absolutely the biggest benefit that I have experienced from being on social media. There is already something so deeply personal about sharing journal pages with others, that it makes you feel wonderful when other like-minded people go out of their way to make contact with you in such a lovely way.

Connection

I will always be so grateful for the kind people I've "met" along this journaling journey. When the world around you feels a little crazy, it's the connections you make with others that remind you of just how lucky you are.

Finish off by using stickers, pressed flowers or washi tape. Muted colours can create a really lovely vintage style.

Layout #43

Add colour around your journal pages to create a border.

Press some texture paste through a stencil to create interesting raised patterns.

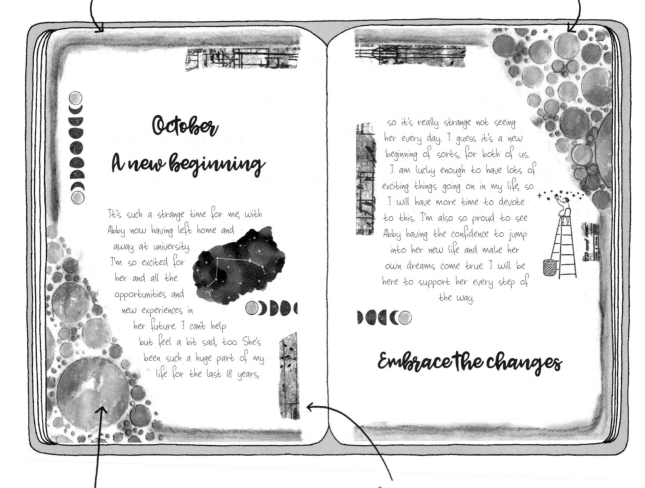

October
A new beginning

It's such a strange time for me, with Abby now having left home and away at university. I'm so excited for her and all the opportunities and new experiences in her future. I can't help but feel a bit sad, too. She's been such a huge part of my life for the last 18 years,

so it's really strange not seeing her every day. I guess it's a new beginning of sorts, for both of us. I am lucky enough to have lots of exciting things going on in my life, so I will have more time to devote to this. I'm also so proud to see Abby having the confidence to jump into her new life and make her own dreams come true. I will be here to support her every step of the way.

Embrace the changes

Use watercolour paint and gelatos (watercolour crayons) to add colour to the texture paste once it has thoroughly dried.

Use stamps and washi tape that all tie into one theme.

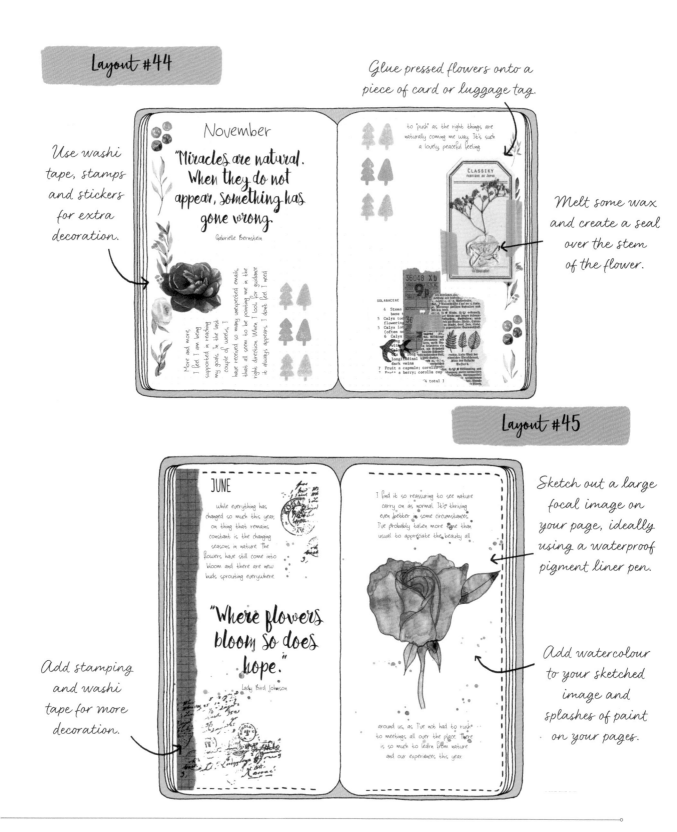

Layout #44

Use washi tape, stamps and stickers for extra decoration.

Glue pressed flowers onto a piece of card or luggage tag.

Melt some wax and create a seal over the stem of the flower.

November

"Miracles are natural. When they do not appear, something has gone wrong."

Gabrielle Bernstein

Layout #45

Sketch out a large focal image on your page, ideally using a waterproof pigment liner pen.

Add watercolour to your sketched image and splashes of paint on your pages.

Add stamping and washi tape for more decoration.

JUNE

"Where flowers bloom so does hope."

Lady Bird Johnson

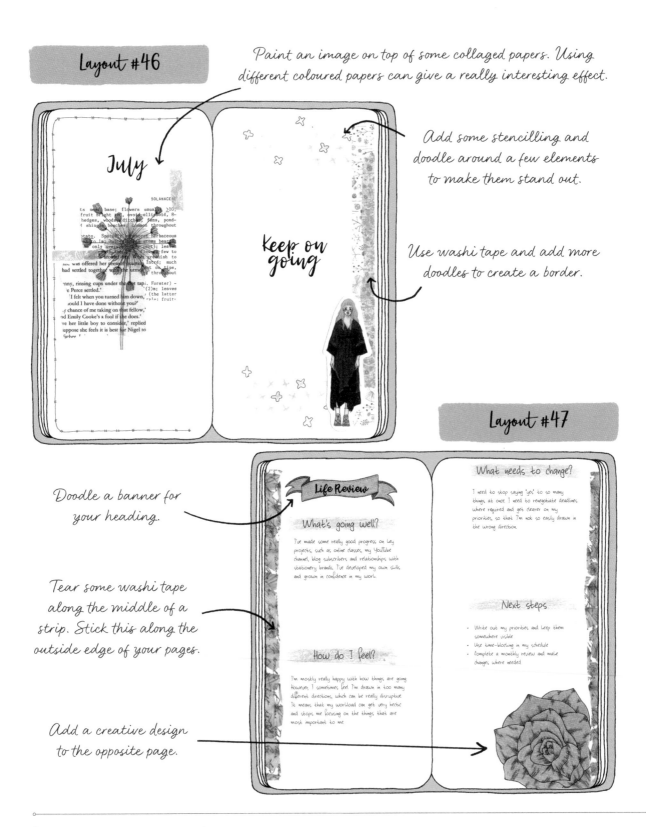

Layout #46

Paint an image on top of some collaged papers. Using different coloured papers can give a really interesting effect.

July

Keep on going

Add some stencilling and doodle around a few elements to make them stand out.

Use washi tape and add more doodles to create a border.

Layout #47

Doodle a banner for your heading.

Tear some washi tape along the middle of a strip. Stick this along the outside edge of your pages.

Add a creative design to the opposite page.

Life Review

What's going well?

I've made some really good progress on key projects, such as online classes, my YouTube channel, blog subscribers and relationships with stationery brands. I've developed my own skills and grown in confidence in my work.

How do I feel?

I'm mostly really happy with how things are going. However, I sometimes feel I'm drawn in too many different directions, which can be really disruptive. It means that my workload can get very hectic and stops me focusing on the things that are most important to me.

What needs to change?

I need to stop saying 'yes' to so many things at once. I need to renegotiate deadlines, where required and get clearer on my priorities, so that I'm not so easily drawn in the wrong direction.

Next steps

- Write out my priorities and keep them somewhere visible
- Use time-blocking in my schedule
- Complete a monthly review and make changes, where needed

WRITING PROMPTS

When you first begin to journal, you may struggle to come up with of topics to write about. Once you get in the habit of keeping a journal, however, you will probably find that you have lots of things to write about, but hopefully these prompts will help you to get started.

214. What is going on in the world around you?

215. What do you spend lots of time thinking about?

216. What is your favourite daydream?

217. Is there anything that is particularly troubling you at the moment?

218. What do you value most in life?

219. What changes are you currently experiencing and how do you feel about them?

220. Are there any adjustments you want to make to the way you live your life?

221. How do you feel at the moment?

222. Are there any great quotes you want to include in your journal?

223. Why are these quotes meaningful to you?

224. What can you celebrate that is going well?

225. What is on your mind when you cannot sleep?

226. If you could change one thing, what would it be?

227. What is your intuition trying to tell you?

228. What difference are you making to the lives of those around you?

229. What is your greatest fear?

230. What obstacles have you successfully overcome?

231. Do you have a daily mantra?

232. Which activities are currently filling you with joy?

233. What lessons have you learnt that you would like to pass on to others?

234. What things are you most passionate about?

235. What are your personal values?

236. How do you make sure you live your life in accordance with your values?

237. How many of your limitations are real? Or are they self-imposed?

238. What letter would you like to send to yourself as a child?

239. Which of your relationships are currently making you feel great?

240. What would happen if you stopped worrying about what other people thought of you?

Memory Keeping

— | — | — | — | — | — | — | — | — | — | — | — |

One of my favourite ways to use a journal is to record special moments and also to document a few things every day that have happened. It is amazing how quickly we can forget all of the little details as we quickly move from one day to the next. When I read back through my journal entries I am often staggered at how much I had already forgotten.

Not only are journals like this wonderful for the person writing them, they can also become a lovely family keepsake for future generations.

Every evening, I jot down in my journal a few lines about the general things that have happened throughout the day. Sometimes these might be big things, but more often they are just the small details that make up my life. I include things like conversations I have had, the changes I am seeing in nature, major events on the news and deadlines I am working towards.

I will dedicate a page or two to more special occasions, where I include photos and notes about what happened. Unlike a traditional photo album, I like to record things that were said, how I was feeling and other prompts that will really bring the memory back to life when I read through it again.

I often get contacted by people who feel their life is not interesting enough to document, but I do not believe that for a minute. We each have a unique perspective on the world and nobody else will live exactly the same life as ours. Every day, I think there is something worth writing about that it is possible to learn from and keep for later reflection.

Add embellishments that tie in with your theme.

Add watercolour stripes around your pages.

stationery and art supplies to play with.

I had a quick bit of creative fun this afternoon before taking Barney to the beach for a walk.

After seeing family, we meet up with friends at the pub for a few drinks. So much laughter.

BIRTHDAY TIME

It was so lovely to meet up with everyone for my birthday. It was a day full of laughter and I feel spoilt rotten.

I started off the day by having a yummy breakfast and then opened my birthday presents. I received some great books, along with fab new

Stick down your photos from the special event.

Draw out some lines on your page, so that you have space for a few notes every day.

Choose a matching design of washi tape to run along the top and sides of your pages.

May

Monday
17
Finished my filming for a brand project this morning. Just need to get it edited and submitted now. The weather was glorious today.

Tuesday
18
Today has felt really long. I hardly got any sleep last night, so it's felt like walking through treacle. Early night needed.

Wednesday
19
Finally finished my magazine submission today. Really happy with how it turned out. Also submitted my brand work. I hope they like it!

Thursday
20
Spent quite a lot of time putting plans together today. Need to get back in control of my workload.

Friday
21
A nice focused end to the week. Replied to all my outstanding emails and finished off a couple of projects. Takeaway night!

Saturday
22
Got a little housework done and then walked down to the market.

Sunday
23
Did a little gardening today and then got my paints out for a play.

Lots of good things happened this week, but there were some frustrating moments, too. I'm really working hard on taking control back of my workload. Learning to say "no" to people would be a good start. I also need to get better at negotiating deadlines. I love what I do, but I need a better balance so I can relax, too.

Add watercolour splotches for the dates, and perhaps add a little painting on the opposite page.

Try using a gold gel pen for a fun effect.

Add stickers for extra decoration.

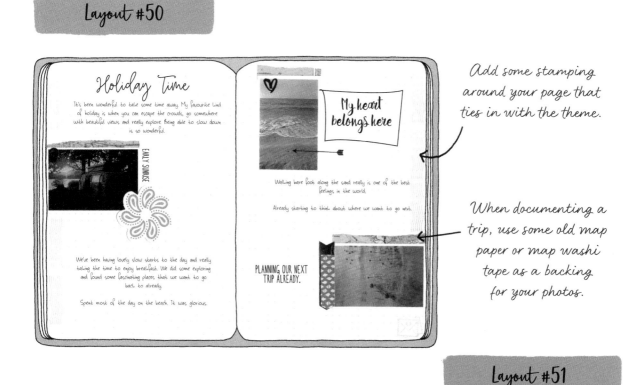

Holiday Time

It's been wonderful to take some time away. My favourite kind of holiday is when you can escape the crowds, go somewhere with beautiful views and really explore. Being able to slow down is so wonderful.

EARLY SUNRISE

We've been having lovely slow starts to the day and really taking the time to enjoy breakfast. We did some exploring and found some fascinating places that we want to go back to already.

Spent most of the day on the beach. It was glorious.

My heart belongs here

Walking bare foot along the sand really is one of the best feelings in the world.

Already starting to think about where we want to go next.

PLANNING OUR NEXT TRIP ALREADY.

Add some stamping around your page that ties in with the theme.

When documenting a trip, use some old map paper or map washi tape as a backing for your photos.

Try creating a doodle for every day that symbolizes something that happened. If you cannot think of anything, food is often a fun starting point. Some people keep the most amazing illustrated food journals.

1st A full-on work day today. I feel like my phone didn't stop ringing. I did my best to help all my clients, but I'm really looking forward to relaxing this evening.

I watched a YouTube video today that has given me so many new ideas. Exciting. **2nd**

3rd I started a new mixed media painting project today. I'm really happy with how it's going so far.

4th Some new clothes I ordered arrived today. It was perfect timing as we are meeting up with friends this evening. Going to get dressed up for a change.

5th Did the not so exciting food shop this morning. It took quite a while as there are lots of new recipes that I really want to try out. Looking forward to getting cooking.

6th It was non-stop rain today. Happy to be working from home.

7th Met up with friends to go bowling tonight. I'm so bad at it, but it was a lot of fun.

8th Finally got around to planting out my seeds in the garden today. Fingers crossed that they all grow well.

9th We walked down to the firework display this evening. They looked spectacular right over the water.

10th A lazy start to the day with croissants for breakfast. It's very indulgent, but a lovely treat every now and then.

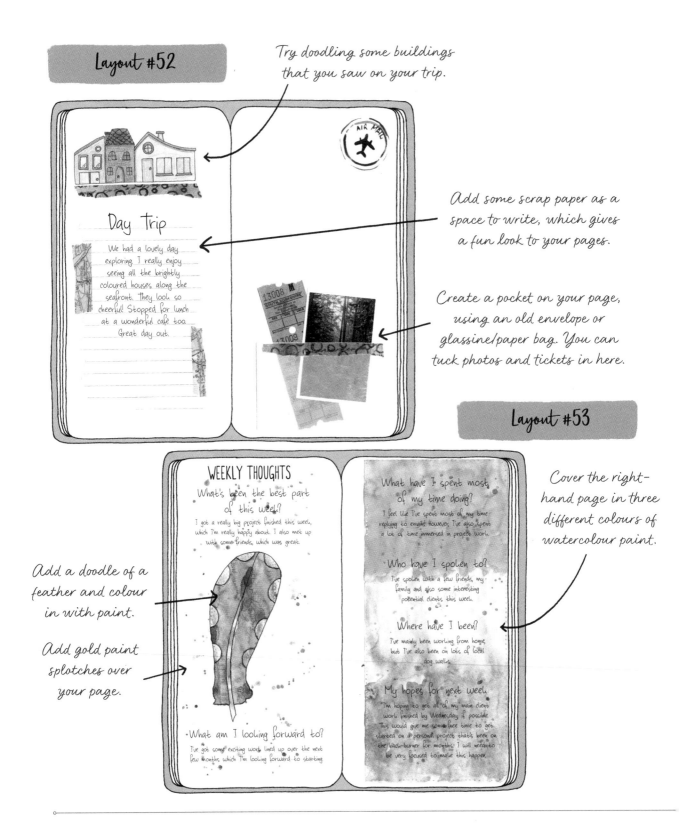

Layout #52

Try doodling some buildings that you saw on your trip.

Day Trip

We had a lovely day exploring. I really enjoy seeing all the brightly coloured houses along the seafront. They look so cheerful! Stopped for lunch at a wonderful café too. Great day out.

Add some scrap paper as a space to write, which gives a fun look to your pages.

Create a pocket on your page, using an old envelope or glassine/paper bag. You can tuck photos and tickets in here.

Layout #53

WEEKLY THOUGHTS

What's been the best part of this week?

I got a really big project finished this week, which I'm really happy about. I also met up with some friends, which was great.

Add a doodle of a feather and colour in with paint.

Add gold paint splotches over your page.

What am I looking forward to?

I've got some exciting work lined up over the next few months which I'm looking forward to starting

What have I spent most of my time doing?

I feel like I've spent most of my time replying to emails! However, I've also spent a lot of time immersed in project work.

Who have I spoken to?

I've spoken with a few friends, my family and also some interesting potential clients this week.

Where have I been?

I've mainly been working from home, but I've also been on lots of local dog walks.

My hopes for next week

I'm hoping to get all of my main client work finished by Wednesday if possible. This would give me some free time to get started on a personal project that's been on the back-burner for months. I will need to be very focused to make this happen.

Cover the right-hand page in three different colours of watercolour paint.

WRITING PROMPTS

Some big events lend themselves really naturally to being documented, but I think there is something worth writing about every day. Once you get in the habit of it, I am sure you will find plenty to write about, but I have included some prompts to help to get you started.

241. How did you feel today?

242. Is it usual for you to feel like that?

243. What conversations did you have today?

244. Did you hear any interesting news?

245. How did you feel about it?

246. What are you looking forward to over the next few days?

247. What was the best part of today?

248. Why did you enjoy it?

249. Do you have any exciting trips or days out coming up?

250. Have you been outside today? Did you see anything of note?

251. What is your favourite time of day? Why?

252. Who is inspiring you at the moment?

253. What things did you laugh at today?

254. How did you feel when you first woke up this morning?

255. What were you thinking about as you started your day?

256. What did you spend most of your time on today?

257. What was your overriding emotion today?

258. Was today better or worse that you expected?

259. What was different about today from yesterday?

260. What are your hopes for tomorrow?

261. Are you feeling good about yourself?

262. What little things did you notice today that are worth remembering?

263. How did today compare to what you were doing this time last year?

264. Would you say that today went to plan?

265. Is there anything worrying you?

266. What has changed your perspective today?

Currently Loving

—．—．—．—．—．—．—．—．—．—．—

A fun way of creating a quick snapshot of your life is to include some "currently loving" pages in your journal. This is where you write down things you are enjoying right now, like the books you are reading, songs you are listening to on repeat or meals that you are currently loving.

I like to document something like this in my journal every month, and it is fascinating to see how much my tastes change over the course of a year. When I look back through old entries, it also reminds me of songs that I had already forgotten about and recipes that I have not tried in ages.

It can also be really lovely to create pages like this for your younger family members, as their preferences are likely to change significantly over quite a short period of time. It can be great fun to remind them of their favourite TV shows, clothes and books as they get older.

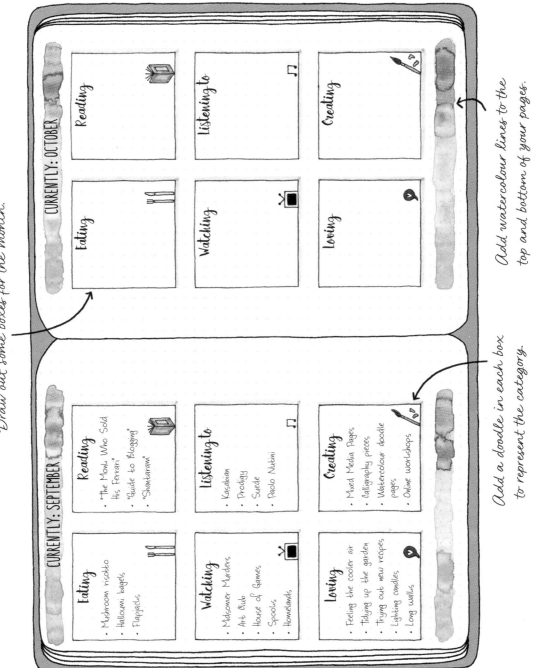

Layout #54

Draw out some boxes for the month.

CURRENTLY: OCTOBER

Reading

Eating

Listening to

Watching

Creating

Loving

Add watercolour lines to the top and bottom of your pages.

CURRENTLY: SEPTEMBER

Reading
- "The Monk Who Sold His Ferrari"
- "Guide to Blogging"
- "Shantaram"

Eating
- Mushroom risotto
- Halloumi bagels
- Flapjacks

Listening to
- Kasabian
- Prodigy
- Suede
- Paolo Nutini

Watching
- Midsomer Murders
- Art Club
- House of Games
- Spooks
- Homelands

Creating
- Mixed Media Pages
- Calligraphy pieces
- Watercolour doodle pages
- Online workshops

Loving
- Feeling the cooler air
- Tidying up the garden
- Trying out new recipes
- Lighting candles
- Long walks

Add a doodle in each box to represent the category.

Create fun doodle pages to visually document
all the things you are currently loving.

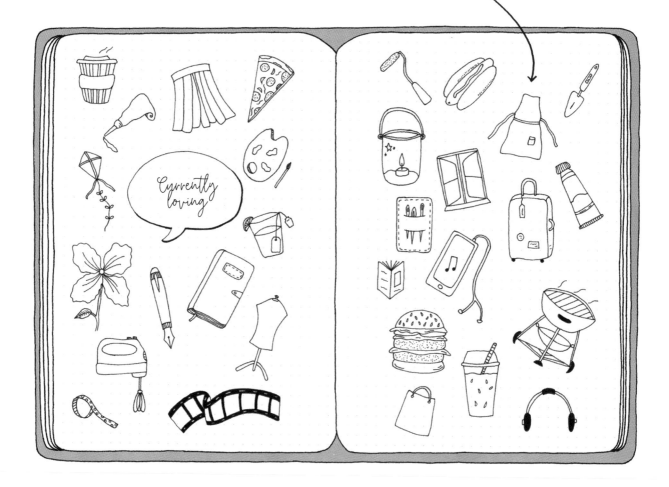

Sketch out an open book.

Sketch out your phone and mock up a playlist design.

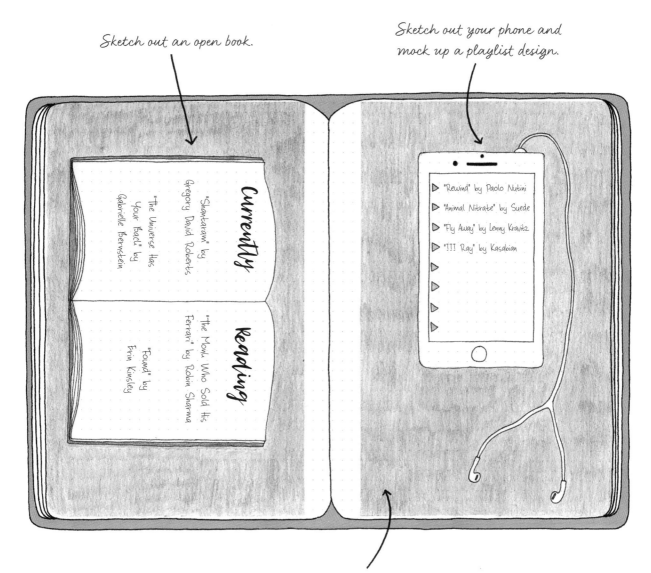

Currently Reading

"Shantaram" by Gregory David Roberts

"The Universe Has Your Back" by Gabrielle Bernstein

"The Monk Who Sold His Ferrari" by Robin Sharma

"Found" by Erin Kinsley

▷ "Rewind" by Paolo Nutini
▷ "Animal Nitrate" by Suede
▷ "Fly Away" by Lenny Kravitz
▷ "III Ray" by Kasabian

Add some background colour to make your drawings stand out on the page.

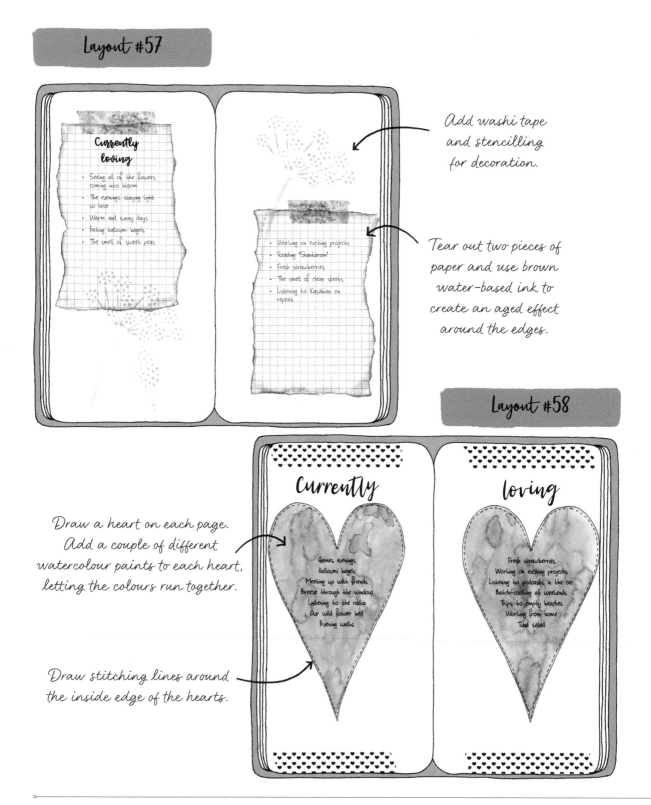

Layout #57

Currently
loving

• Seeing all of the flowers coming into bloom
• The evenings staying light so late
• Warm and sunny days
• Eating halloumi bagels
• The smell of sweet peas

• Working on exciting projects
• Reading "Shantaram"
• Fresh strawberries
• The smell of clean sheets
• Listening to Kasabian on repeat

Add washi tape and stencilling for decoration.

Tear out two pieces of paper and use brown water-based ink to create an aged effect around the edges.

Layout #58

Currently loving

Games evenings
Halloumi bagels
Meeting up with friends
Breeze through the window
Listening to the radio
Our wild flower bed
Evening walks

Fresh strawberries
Working on exciting projects
Listening to podcasts in the car
Batch-cooking at weekends
Trips to empty beaches
Working from home
Tuna salad

Draw a heart on each page. Add a couple of different watercolour paints to each heart, letting the colours run together.

Draw stitching lines around the inside edge of the hearts.

WRITING PROMPTS

The Currently Loving pages are a really fun way to quickly capture this specific moment in your life. Have a think about some of the following prompts, to see what you could record.

267. What songs are you listening to on repeat?

268. What always makes you smile and leaves you instantly happier?

269. Which books are you currently reading?

270. What are you favourite foods to eat right now?

271. Which recipes have you tried recently?

272. What brings you comfort?

273. What hobbies are you enjoying and doing a lot of at the moment?

274. What creative projects are you working on?

275. What TV programmes are you most enjoying?

276. What is your favourite outfit?

277. Which scent or perfume are you using the most?

278. Where are you favourite places to visit?

279. Where is you favourite place to eat?

280. What podcasts are you listening to?

281. What games are you playing?

282. What are you focusing on at work?

283. What subscriptions do you currently have?

284. Which stationery items are you using the most?

285. What are you binge-watching?

286. What colours are showing up the most on your journal pages?

287. Which magazines are you currently reading?

288. What is the first thing you do every day?

289. Who are you spending the most time with?

290. What is the last thing you do every day?

291. What is the weather like at the moment?

292. What subjects do you spend the most time thinking about?

Be Proud of Yourself

These particular journal pages have had a really positive impact on my life and I do hope you will give them a try. The aim is to take some time out every day to offer yourself a little praise. I find it is really easy to focus on the things that I feel I have not done so well at and completely overlook all of the mini accomplishments that I achieve every day.

Before keeping these types of pages, I would spend the evening thinking about mistakes I had made, projects I was falling behind on, or anything I felt I should have done better at. It was exhausting and left me feeling deflated, with a negative swirling of thoughts in my head that often carried over into the next morning.

While I think it is important to learn from things that go wrong, I think it is even more vital to celebrate all the things we get right. Our brains seem auto-tuned to concentrate on the negative, giving us a distorted view of ourselves and the world. With a little persistence, these pages can really help your brain to look out for and focus on the things that you do well, which is a much happier way to live.

Each evening, I reflect on my day and think of one or two of things that I should be proud of, then I jot them down. These are rarely huge accomplishments, but they are little successes nonetheless. Typical entries include making healthier food choices, coping well with a change to my plans, drinking lots of water, learning a new skill, dealing with something I had been putting off or just tidying up the house.

Even if it seems false at first, I recommend trying this type of journaling and sticking with it until you start to notice the changes. It can make such a difference to how you view yourself and it encourages you to achieve more the next day so that you have plenty to write down. I find that throughout the day I actually notice the areas where I am doing well much more readily than I ever would have done before. I do not ignore the things that I need to improve on, but offering myself praise for the things that I get right really helps to give me the mindset I need to tackle any problem areas.

Tear a strip of washi tape along the middle and stick one half to the outside edge of each page, with the torn edges facing inwards.

Reasons to be Proud: August

Reasons to be Proud: July

Released a new blog post.
Making healthier food choices.
Planned out meals for the week.
Organized my time well.
Stood up for myself.
Made my voice heard.
Prioritising well.
Spending my time on the things that matter most.
Learning new creative skills.
Tidied up the house.
Replied to all emails.

Add a few floral doodles to your pages, or use stamps for quick decoration.

Draw an envelope on each page, with a letter coming out.

Add striped lines using a brush pen.

Be proud of yourself

While things are quite challenging at the moment, I am staying cheerful and just focusing on one day at a time. I have started time-blocking to ensure that I stay focused throughout the day. It's helped me to avoid distractions and becoming too bogged down in things.

Add stickers for extra decoration.

Layout #61

Doodle a variety of fun writing spaces on your pages.

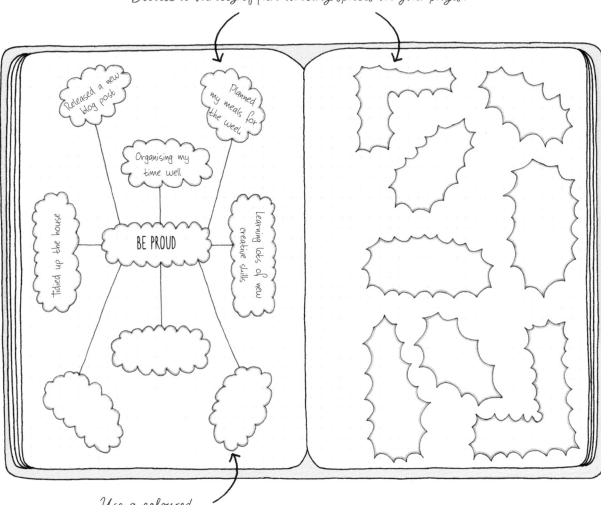

Released a new blog post

Planned my meals for the week

Organising my time well

tidied up the house

BE PROUD

Learning lots of new creative skills

Use a coloured pen to highlight around the lines.

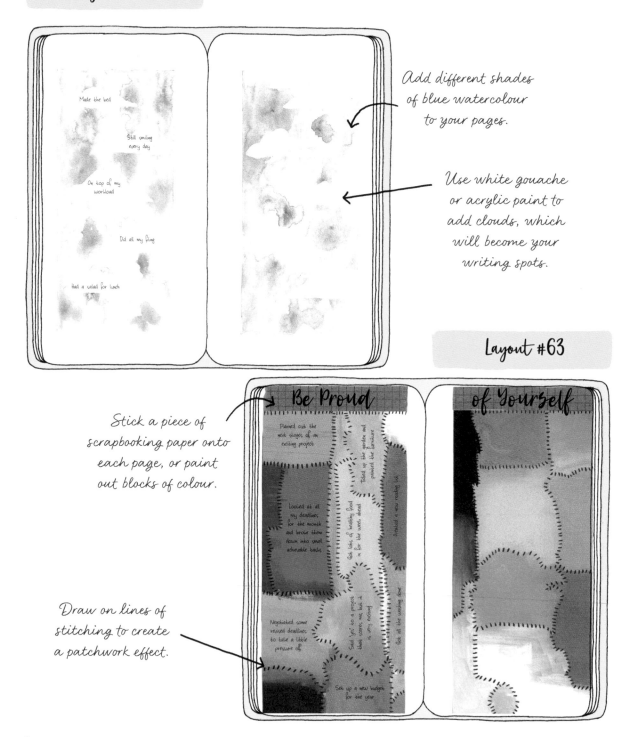

Layout #62

Made the bed

Still smiling every day

On top of my workload

Did all my filing

Had a salad for lunch

Add different shades of blue watercolour to your pages.

Use white gouache or acrylic paint to add clouds, which will become your writing spots.

Layout #63

Stick a piece of scrapbooking paper onto each page, or paint out blocks of colour.

Be Proud of Yourself

Planned out the next stages of an exciting project

Ticked up the garden and painted the furniture

Looked at all my deadlines for the month and broke them down into small achievable tasks

Got lots of healthy food in for the week ahead

Booked a new reading list

Negotiated some revised deadlines to take a little pressure off

Said 'yes' to a project that scares me, but it is very exciting

Got all the washing done

Set up a new budget for the year

Draw on lines of stitching to create a patchwork effect.

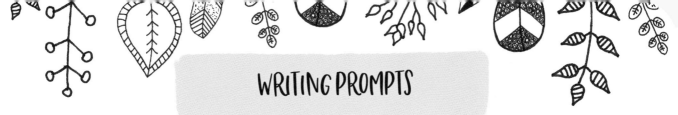

WRITING PROMPTS

Hopefully you are finding lots of things to be proud of about yourself, but if you are struggling a little, then these prompts should help you to get started.

293. What are you most proud of today?

294. What good choices have you made?

295. In what ways have you helped others?

296. Which job did you find difficult, but tried your best at anyway?

297. What did you tick off your "to-do" list?

298. In what ways are you making an effort to improve your life?

299. What new things have you attempted recently?

300. What positive changes have you made for yourself and others?

301. What are you good at that others find difficult?

302. Who do you help to take care of?

303. What little things did you get done today?

304. What progress have you made on a big project?

305. What negative thought patterns have you been able to work on or stop?

306. What are you doing better at now than you were a year ago?

307. What is your best quality?

308. In what ways do you remain true to your values?

309. Which things have you learnt to say no to?

310. In which parts of your life have you learnt to let yourself go?

311. What have you achieved that you previously never thought possible?

312. What lessons have you learnt?

313. Which skills are you currently working on improving?

314. What have you done to improve your own mental well-being?

315. What positive food and nutrition choices have you been making?

316. What is better in your life now than it was this time last year?

317. What things do you care about?

318. How have you helped to find a positive outcome for a difficult situation?

Health & Well-being

/////////////////////////////

One of the most common areas to neglect, is taking the time to look after our physical and mental well-being. We can get so busy with all the demands of work and home, along with looking after others, that it can be difficult to make ourselves a priority. Yet, when we do not look after ourselves properly, we can start to lose energy and become unwell, making everything else much more difficult.

In this section, I am going to share some health and well-being pages that you can use in your own journal. They will help you to make the time to focus on the things that will keep you as happy and healthy as possible.

I have found that creating a meal-planning spread can be really useful. It helps you to plan the groceries you need to pick up, saves time making decisions about what to eat each day and can also help you to make healthier food choices.

I also like to set some fitness goals for myself, as this helps to keep me accountable. Even if I do not reach all of the goals, I know that I have made more progress than I would have done if they were not written down at all.

A morning and evening routine can be so useful when it comes to prioritizing your own needs. Try writing out your ideal routine and then sticking as closely to it as possible, making sure to include plenty of activities that make you feel good.

Alongside this, a healthy habits tracker can give you a great visual representation of how you are getting on and will also highlight any areas that perhaps need a bit more focus. You can of course adapt any of these spreads to make sure they suit your own needs and help you to find that important balance.

planning

	Fri	Sat	Sun	Shop
Brekkie				Eggs, Bread, Orange juice, Marmite, Milk
Lunch				Bagels, Potatoes, Cottage cheese, Salad, Halloumi
Dinner				Chicken, Pork, Minced beef, Coleslaw, Vegetables
Snacks				Carrots, Hummus, Rice cakes, Butter

meal

	Mon	Tues	Weds	Thurs
Brekkie	Cereal, Orange juice	Toast and marmite, Banana	Poached eggs on toast, Smoothie	Cereal and fresh berries
Lunch	Omelette and salad, Fruit	Halloumi bagel, Tomatoes	Tuna sandwich, Yoghurt	Jacket potato and cottage cheese
Dinner	Chicken curry and rice	Maple pork, salad and coleslaw	Spaghetti bolognese and garlic bread	Lemon zest chicken and Mediterranean veg
Snacks	Carrot sticks and hummus	Rice cakes	Oaty cookies	Rice cakes

Doodle some fruit and veg along the top.

Draw out the grid lines for a meal-planning page.

Use brightly coloured pencils and blend them into each other for a fun effect.

Layout #65

Draw out boxes for different areas
related to your fitness goals.

Health & Fitness

YOGA WORKOUTS
Yoga with Adriene x 3 classes per week
10 minute stretch each morning

WEIGHT TRAINING
2 x weight training sessions per week
1 x upper body
1 x lower body

CARDIO WORKOUTS
1 x 30 minute run
1 x Zumba

MEASUREMENTS
Waist
Hips
Thighs
Arms

Add a doodle in each section
to tie in with the theme.

Use highlighter pens and washi
tape to add extra decoration.

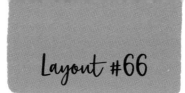

Draw out boxes for your morning
and evening routines.

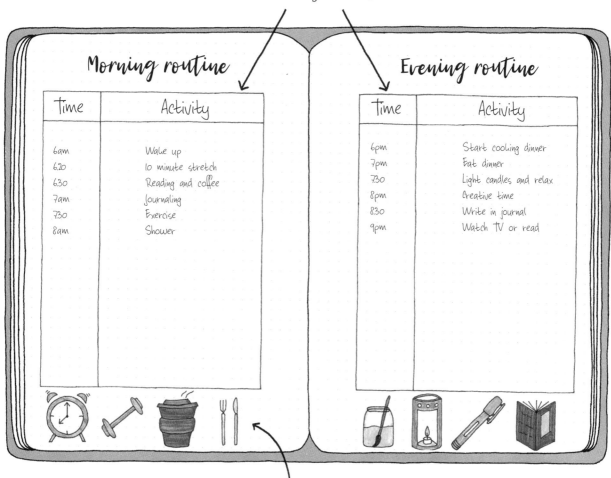

Morning routine

Time	Activity
6am	Wake up
6.20	10 minute stretch
6.30	Reading and coffee
7am	Journaling
7.30	Exercise
8am	Shower

Evening routine

Time	Activity
6pm	Start cooking dinner
7pm	Eat dinner
7.30	Light candles and relax
8pm	Creative time
8.30	Write in journal
9pm	Watch TV or read

Add doodles along the bottom
which represent activities
you want to incorporate.

Layout #67

Relax

- Candles and oil burners and turn down the lights
- Have a long bath
- Walk in nature
- Listen to music

Mental Health

- Turn off social media
- Write in my journal
- Get creative and play with paint

- Watch comedy programmes
- Listen to podcasts
- Read positive books
- Meditate

Physical Care

- Regular exercise
- Face masks
- Book in for a massage
- Do my nails
- Stretching and yoga
- Apply body lotion
- Deep-condition hair
- Get good amounts of sleep

Letter out some headings.

Doodle a branch under each heading.

Add decorative washi tape.

Layout #68

Draw or stamp out a tracker on each page.

Add decoration by using a stencil or embellishments.

Add an icon to the lines of the tracker for each healthy habit that you want to focus on.

w/c 7th June — Water, Good sleep, Fruit and veg, Exercise, Relaxed time

w/c 14th June — Water, Good sleep, Fruit and veg, Exercise, Relaxed time

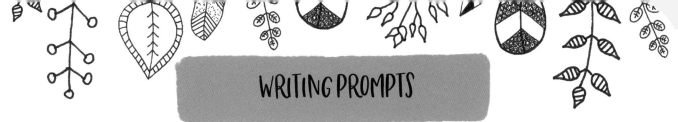

WRITING PROMPTS

Take a little time to think about the ways that you want to focus on your own health and well-being, to ensure you are prioritizing yourself.

319. What meals would you like to eat this week?

320. What healthy snacks could you choose?

321. How much time do you have to prepare healthy home-cooked meals?

322. Which kinds of food make you feel really good?

323. What health goals do you have?

324. What type of exercise do you want to focus on?

325. How much time each week do you want to devote to exercise?

326. What type of exercise do you enjoy?

327. What fitness goals do you have?

328. How is your health and fitness compared to one year ago?

329. What changes could you make to your lifestyle that would make the most difference to you?

330. What kind of activities would give you a really good start to the day?

331. How much time could you find for yourself before starting work in the morning?

332. What sort of activities help you to relax in the evening and get a good night's sleep?

333. What time do you stop checking your phone and email notifications in the evening?

334. What is your favourite way to unwind?

335. How much time do you typically take each day to care for your physical and mental well-being?

336. Is there a way that you could increase this amount if it does not feel enough?

337. Which healthy habits would really improve your quality of life?

338. What does a healthy lifestyle look like to you?

339. How would it feel if you could achieve this?

340. What small change could you make from today?

341. Are there any great YouTube videos that could help to inspire you on your journey?

342. What milestones or mini targets could you set to challenge yourself?

343. Which activities feel the most nourishing for your mental health?

344. Who can inspire you and support you while you are working towards your goals?

Make a Difference

Keeping a journal has allowed me to reflect often on the impact that we can have on the people we come into contact with. When I read back through my journal entries, they are often full of conversations I have had with others, along with details of how those interactions have made me feel. Sometimes those people have really brightened my day, leaving me brimming with inspiration and full of hope for the future. On other occasions, the conversation has been less positive, leaving me doubting myself, feeling frustrated or even a bit resentful.

By fully realising the value of these interactions, it has made me more determined to try and ensure that I have a positive impact on the world around me and spend my time in the right way. I use my journal to reflect on my behaviour and how I have treated others, and to look at ways that I can try and spread a little kindness. I really think that each of us can make a big difference, with just a few small acts of kindness each day. If we are focused on making other people feel good, it is really likely that they will leave interactions with us in a positive frame of mind and go on to make other people feel happier, too.

A huge benefit of making a positive difference in other people's lives is that not only do you make them feel good, but it will help you to feel better about yourself at the same time, with a life full of purpose. Research shows that being kind to others can also have a positive impact on our mental health, so it really is a "win-win" situation.

In this section, I am going to be focusing on creating "kindness quote" pages as a reminder, looking at where we can create the most impact, coming up with new ideas and setting ourselves a 30-day kindness challenge.

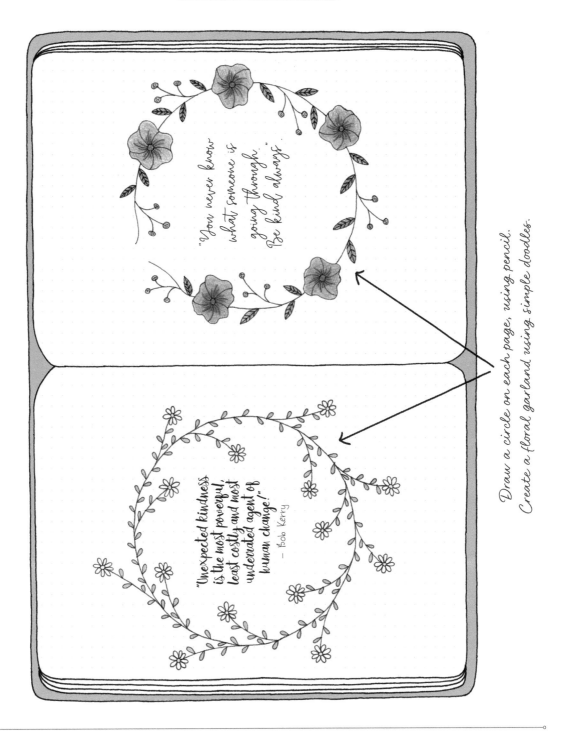

"You never know what someone is going through. Be kind always."

"Unexpected kindness is the most powerful, least costly and most underrated agent of human change!"
— Bob Kerry

Draw a circle on each page, using pencil.
Create a floral garland using simple doodles.

Layout #70

Draw out four boxes on your pages.

Add ribbon banners along the top.

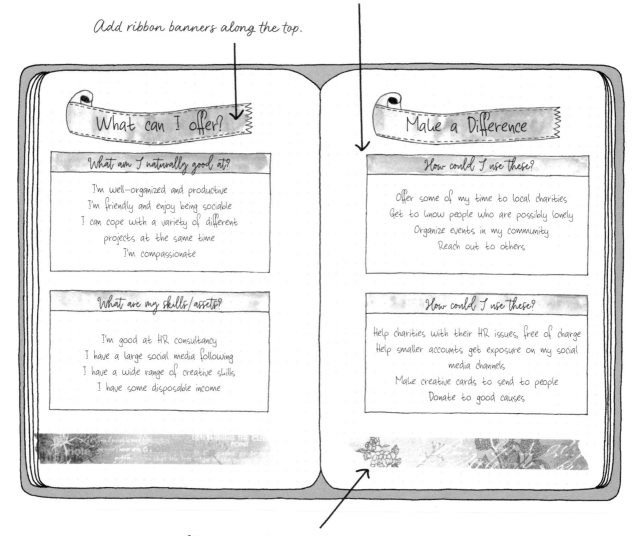

What can I offer?

What am I naturally good at?

I'm well-organized and productive
I'm friendly and enjoy being sociable
I can cope with a variety of different
projects at the same time
I'm compassionate

What are my skills/assets?

I'm good at HR consultancy
I have a large social media following
I have a wide range of creative skills
I have some disposable income

Make a Difference

How could I use these?

Offer some of my time to local charities
Get to know people who are possibly lonely
Organize events in my community
Reach out to others

How could I use these?

Help charities with their HR issues, free of charge
Help smaller accounts get exposure on my social
media channels
Make creative cards to send to people
Donate to good causes

Use watercolour paint or pencil,
along with washi tape to decorate.

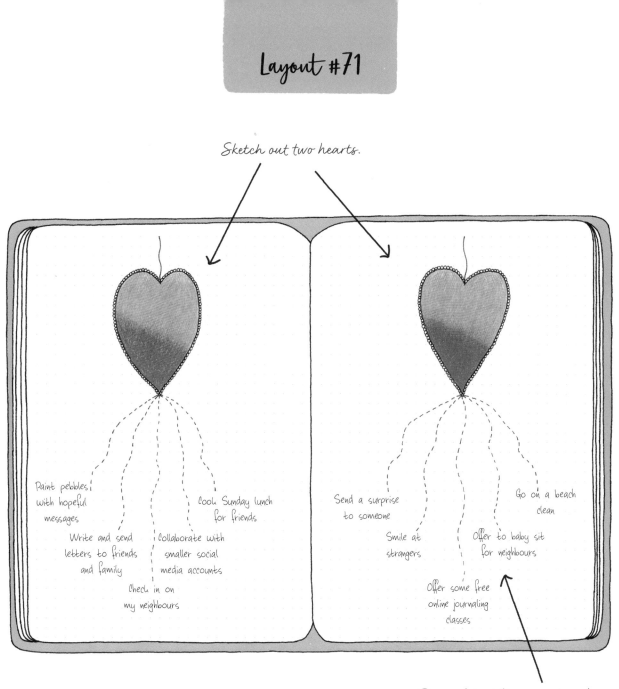

Sketch out two hearts.

Paint pebbles with hopeful messages

Write and send letters to friends and family

Collaborate with smaller social media accounts

Cook Sunday lunch for friends

Check in on my neighbours

Send a surprise to someone

Smile at strangers

Offer to baby sit for neighbours

Go on a beach clean

Offer some free online journaling classes

Draw dotted lines coming down from the hearts with room underneath to add your ideas.

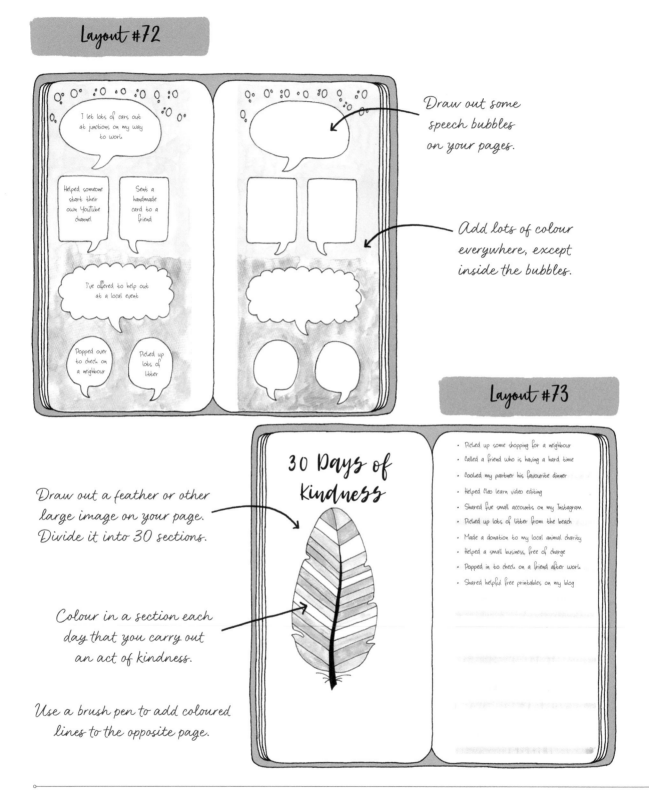

Layout #72

Draw out some speech bubbles on your pages.

Add lots of colour everywhere, except inside the bubbles.

Layout #73

Draw out a feather or other large image on your page. Divide it into 30 sections.

Colour in a section each day that you carry out an act of kindness.

Use a brush pen to add coloured lines to the opposite page.

WRITING PROMPTS

There are so many lovely ways that we can make a positive impact on the world. These prompts are designed to get you thinking about the difference you can make.

345. Which quotes could you include in your journal that will remind you to focus on kindness?

346. How do those quotes make you feel?

347. What are you naturally good at?

348. How could you use this to help others and make a difference?

349. What are your skills and assets?

350. How could you use these to the benefit of others?

351. When was the last time that someone showed you kindness?

352. How did this make you feel?

353. When was the last time you did something kind for someone else?

354. How did that make you feel?

355. What can you learn from these interactions?

356. What other small acts of kindness could you do for other people?

357. If you are short of ideas, try looking up "acts of kindness" online. There are some really inspirational stories that are bound to give you some fresh inspiration to jot down in your journal.

358. What positive impact could you make in your local community?

359. What act of kindness could you perform within your own family?

360. How different do you think the world would be if everybody focused on kindness?

361. Do people feel better or worse after their interactions with you?

362. What kind of example do you set for others?

363. How good are you at stopping to think about the impact of your actions before you react?

364. What does the word "kindness" mean to you?

365. Which role models could guide your actions?

366. Is there something that would stop you from being able to offer kindness?

367. Is there a charity you would like to become more involved with?

368. Is there a particular cause where you would like to make a difference?

Once you have made kindness a regular part of your life, think about the following prompts:

369. How much have you been able to achieve over the course of six months?

370. What difference has this made to your life and the lives of others?

Goal Setting

Another great way of using your journal is to set out all your dreams and goals for the future. Research has shown that for some reason we become far more committed to our goals when we set them down on paper, rather than typing them electronically. I am not sure if it is the physical act of writing them out that causes this, but it has definitely worked for me. I also leave my journal open on certain pages, which acts as a great reminder, whereas my electronic documents tend to get forgotten about.

Your journal can act as a really safe space to clarify what you want out of life, with no limitations, and then start gradually planning out how you can work towards each goal. I really enjoy looking back at my journals from a few years ago and seeing how many goals I have achieved that seemed pretty impossible at first. It helps spur me on to set even bigger, bolder goals, safe in the knowledge that I can use my journal to set me on the right track.

In this section, I am going to guide you through creating a vision board, which is one of my favourite things to do, putting detailed plans in place that will help you to start working towards those big ideas. Lots of my goals and priorities have changed over time, but it was through using these methods in my journal that I gained much more clarity on what was important to me and what lifestyle I really wanted. It has also been through working towards these goals that unexpected opportunities have presented themselves, which I could not even have imagined beforehand.

I hope you have lots of fun with these journal pages. Try not to limit yourself or worry about the practicalities too much in the beginning, as this is the time to let your mind and dreams develop to create ideas as big as you would like. You never know what is possible until you try.

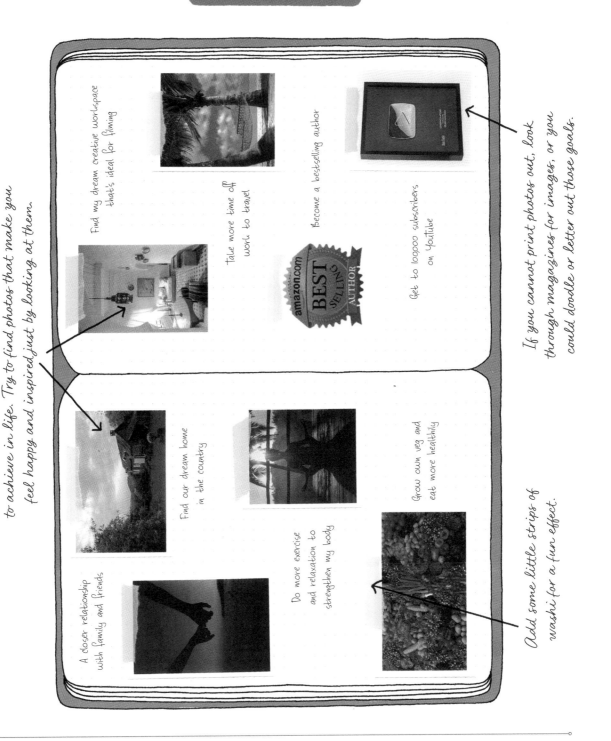

Layout #74

Find images that symbolize the goals you most want to achieve in life. Try to find photos that make you feel happy and inspired just by looking at them.

Find my dream creative workspace that's ideal for filming

Take more time off work to travel

Become a bestselling author

Get to 100000 subscribers on YouTube

If you cannot print photos out, look through magazines for images, or you could doodle or letter out those goals.

A closer relationship with family and friends

Find our dream home in the country

Do more exercise and relaxation to strengthen my body

Grow own veg and eat more healthily

Add some little strips of washi for a fun effect.

Layout #75

Draw out a box for each area of your life that you want to work on.

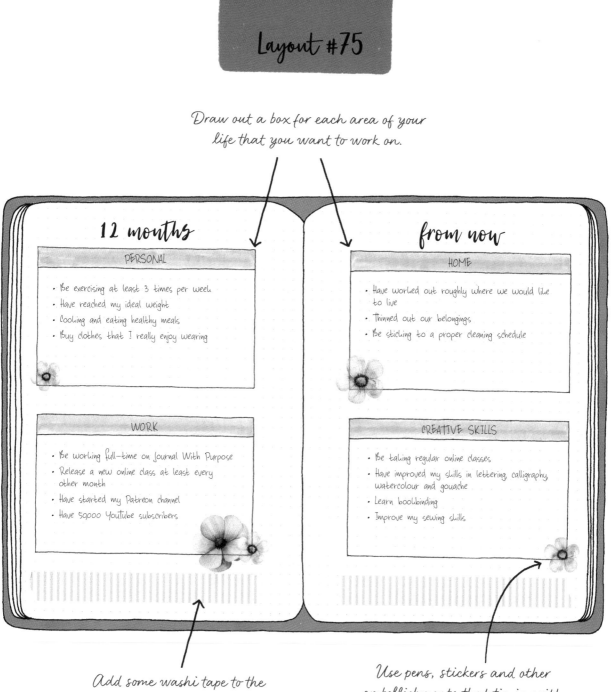

12 months

PERSONAL
- Be exercising at least 3 times per week
- Have reached my ideal weight
- Cooking and eating healthy meals
- Buy clothes that I really enjoy wearing

WORK
- Be working full-time on Journal With Purpose
- Release a new online class at least every other month
- Have started my Patreon channel
- Have 50,000 Youtube subscribers

from now

HOME
- Have worked out roughly where we would like to live
- Thinned out our belongings
- Be sticking to a proper cleaning schedule

CREATIVE SKILLS
- Be taking regular online classes
- Have improved my skills in lettering, calligraphy, watercolour and gouache
- Learn bookbinding
- Improve my sewing skills

Add some washi tape to the bottom of your pages.

Use pens, stickers and other embellishments that tie in with the colour of your washi.

Layout #76

Turn your journal around and
draw out two large boxes.

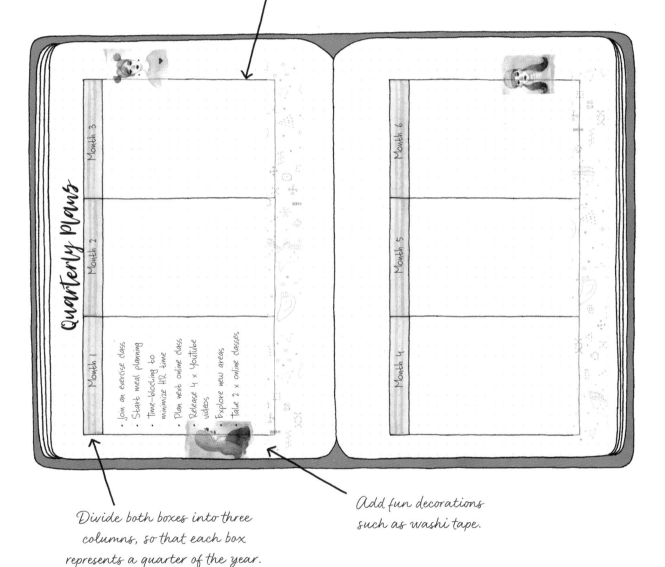

Quarterly Plans

Month 3

Month 2

Month 1

- Join an exercise class
- Start meal planning
- Time-blocking to minimize HR time
- Plan next online class
- Release 4 x Youtube videos
- Explore new areas
- Take 2 x online classes

Month 6

Month 5

Month 4

Divide both boxes into three
columns, so that each box
represents a quarter of the year.

Add fun decorations
such as washi tape.

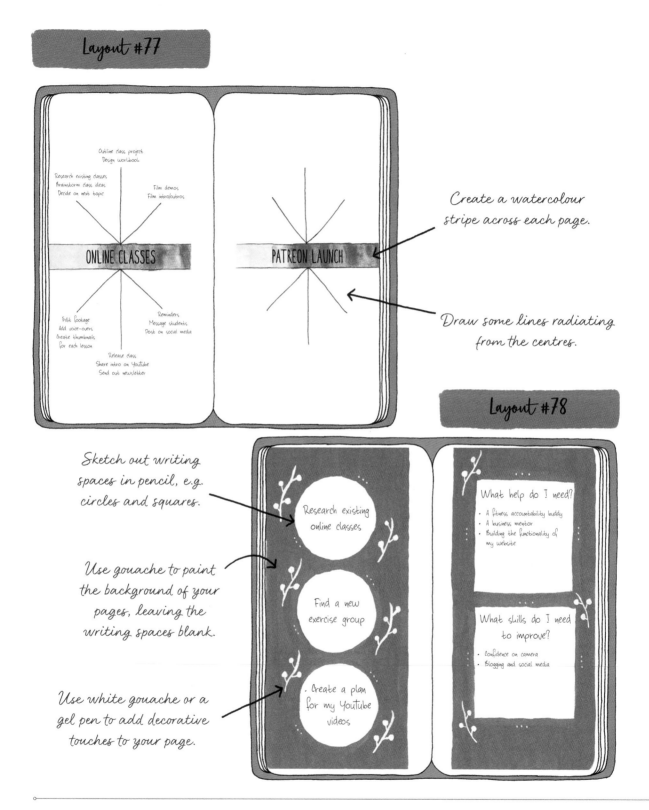

Layout #77

Outline class project
Design workbook.

Research existing classes
Brainstorm class ideas
Decide on next topic

Film demos
Film intro/outros

ONLINE CLASSES

Edit footage
Add voice-overs
Create thumbnails
for each lesson

Reminders
Message students
Post on social media

Release class
Share intro on Youtube
Send out newsletter

PATREON LAUNCH

Create a watercolour stripe across each page.

Draw some lines radiating from the centres.

Layout #78

Sketch out writing spaces in pencil, e.g. circles and squares.

Research existing online classes

Find a new exercise group

Create a plan for my Youtube videos

Use gouache to paint the background of your pages, leaving the writing spaces blank.

Use white gouache or a gel pen to add decorative touches to your page.

What help do I need?

- A fitness accountability buddy
- A business mentor
- Building the functionality of my website

What skills do I need to improve?

- Confidence on camera
- Blogging and social media

WRITING PROMPTS

When setting your goals, it can be useful to take a little time to reflect before committing your ambitions to paper. Answer some of the following prompts to get you thinking about your ideal future.

371. What are your biggest goals for the future?

372. Why are these important to you?

373. How would you feel if you reached these goals?

374. Do any of these ambitions scare you?

375. If you could do any job you wanted, what would it be?

376. What sort of home do you want to live in?

377. Describe your perfect lifestyle.

378. What personal aspirations do you have for your own health and well-being?

379. What amazing skill would you love to master?

380. Where would you most like to live?

381. What do you think could be achievable over the next three months?

382. Which tasks could you aim to complete by the end of this month that will take you closer to achieving your goals?

383. Write out the headings of some big projects that support your goals. Now list every task you can think of that will be required for you to complete this project.

384. What are the next three tasks that would start moving you in the right direction?

385. What help do you need to achieve your goals?

386. What skills do you need to improve to make your journey easier?

387. Print out some photos that represent your dream life and create a vision board.

388. How do you feel about your vision board?

389. What difference would it make to your life if you accomplished even one of these goals?

390. Which goal feels most important to you right now?

391. Write down a journal entry describing your day, imagining you have already reached your goals. Describe your day in detail and really imagine those accomplishments.

392. Who has already achieved some of the goals you have set for yourself?

393. What could you learn from them and their personal journey?

394. What steps can you take to make sure you enjoy life whilst working towards these fantastic goals?

395. Which milestones are worth celebrating along the way?

396. In what way are you going to hold yourself accountable for achieving these goals?

Project Planning

Using your journal to plan out big projects is a great way to stay organized and on top of the tasks and deadlines that you need to meet. The main projects you plan out might be for work, but you could easily use the same type of journal pages for planning out things around the home, fitness goals or a personal passion project.

I have used my journal to plan out house moves, planting plans for the garden, decluttering my home, learning new creative skills and for releasing new online classes. It is really helpful for anything you want to work towards that has lots of individual steps or tasks that need completing.

In this section, I will be sharing ideas for creating a whole project overview, project trackers, creating a Gantt-style bar chart and time-blocking. I tend to include tabs on the side of my project journal pages, as this helps me to find them easily when I am working on those projects. If the project is likely to take longer than your current journal will last you, it might be worth considering a separate journal just for large project planning.

Keeping these types of pages in my journal encourages me to review my progress on a regular basis and make any changes to my schedule that will help me to stay on track. I also refer back to them when I am starting a new project, to see what I can learn and improve on.

Tasks

- Review the classes that are performing well
- Create a really engaging class project
- Write out a detailed plan for each of the lessons
- Type up a clear and inviting class description

Notes

- Look into best audio microphone
- Consider a giveaway
- Schedule follow-up marketing for April
- Ask for feedback on the class

Project Launch new online class

Start 1st Jan End 31st Mar

Aim to launch a new online class that leaves students excited to try new techniques in their journal

Milestones

	Date
Research stage	10/1
Outline class project	12/1
Plan out each lesson	25/1
Type up description	3/1
Film demos	20/2
Film "talking heads"	28/2
Edit footage and voice-overs	15/3
Load all sections	20/3
Release class	30/3
Marketing	31/3
Follow-up in April	

Draw out boxes on your pages.

Add highlighter pen and stickers in matching colours.

Layout #80

Create headings for your Gantt chart.

ACTIVITY	MONTH 1	MONTH 2	MONTH 3
Update statistics			
Email marketing			
Youtube videos			
Blog posts			
Planning sessions			
Follow-up calls			
Photography			
Schedule posts			
Class promotion			
Student feedback			
Load new projects			
Class prompts			
Review this quarter			
Plan for next quarter			

Select different coloured pens for marking the
dates you want to allocate to specific activities.

Layout #81

Draw out some boxes.

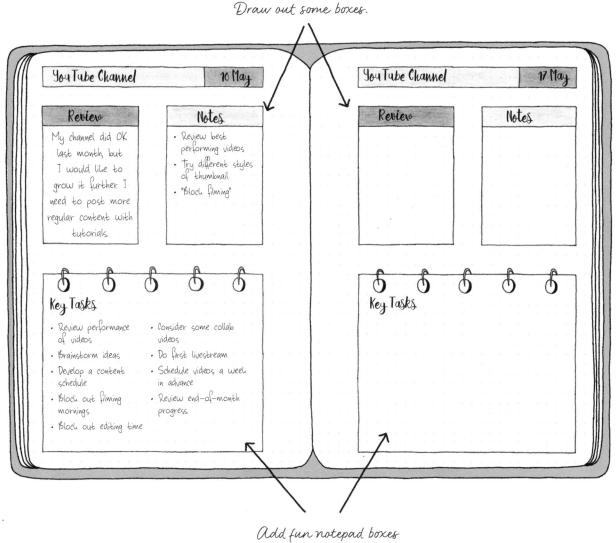

YouTube Channel	10 May

Review

My channel did OK last month, but I would like to grow it further. I need to post more regular content with tutorials.

Notes

- Review best performing videos
- Try different styles of thumbnail
- "Block filming"

Key Tasks

- Review performance of videos
- Brainstorm ideas
- Develop a content schedule
- Block out filming mornings
- Block out editing time
- Consider some collab videos
- Do first livestream
- Schedule videos a week in advance
- Review end-of-month progress

YouTube Channel	17 May

Review

Notes

Key Tasks

Add fun notepad boxes at the bottom.

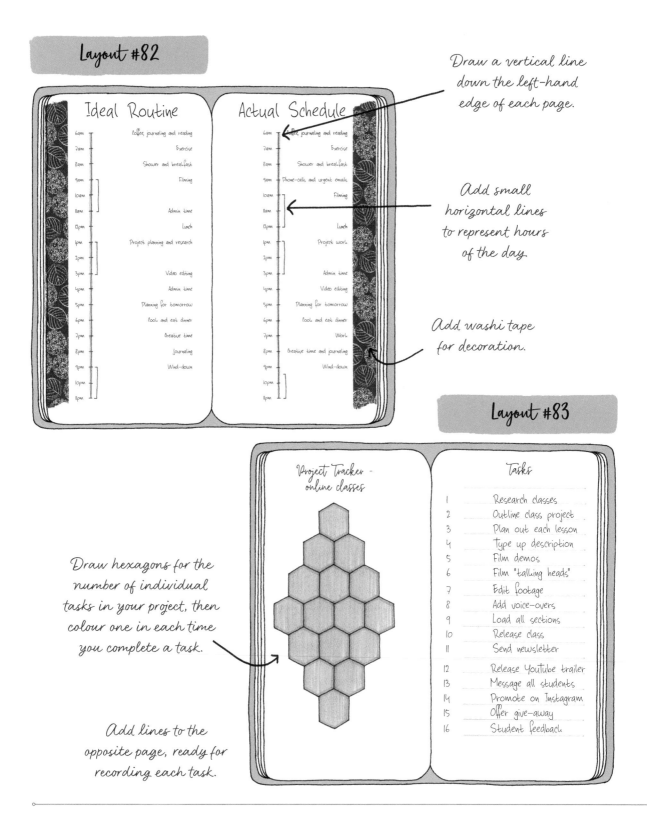

Layout #82

Ideal Routine

6am	Coffee, journaling and reading
7am	Exercise
8am	Shower and breakfast
9am	Filming
10am	
11am	Admin time
12pm	Lunch
1pm	Project planning and research
2pm	
3pm	Video editing
4pm	Admin time
5pm	Planning for tomorrow
6pm	Cook and eat dinner
7pm	Creative time
8pm	Journaling
9pm	Wind-down
10pm	
11pm	

Actual Schedule

6am	Coffee, journaling and reading
7am	Exercise
8am	Shower and breakfast
9am	Phone-calls and urgent emails
10am	Filming
11am	
12pm	Lunch
1pm	Project work
2pm	
3pm	Admin time
4pm	Video editing
5pm	Planning for tomorrow
6pm	Cook and eat dinner
7pm	Work
8pm	Creative time and journaling
9pm	Wind-down
10pm	
11pm	

Draw a vertical line down the left-hand edge of each page.

Add small horizontal lines to represent hours of the day.

Add washi tape for decoration.

Layout #83

Project Tracker – online classes

Tasks

1	Research classes
2	Outline class project
3	Plan out each lesson
4	Type up description
5	Film demos
6	Film "talking heads"
7	Edit footage
8	Add voice-overs
9	Load all sections
10	Release class
11	Send newsletter
12	Release Youtube trailer
13	Message all students
14	Promote on Instagram
15	Offer give-away
16	Student feedback

Draw hexagons for the number of individual tasks in your project, then colour one in each time you complete a task.

Add lines to the opposite page, ready for recording each task.

WRITING PROMPTS

Facing a big project with lots of tasks can feel a little daunting. These prompts are designed to help guide you through planning a project in your journal.

397. Which project do you really want to focus on at the moment?

398. Why is this project important to you?

399. When do you plan to start working on it?

400. What is the deadline or date that you would like to finish it by?

401. Is there any flexibility with this deadline?

402. What is the aim or purpose of this project?

403. What milestones are there that will help you track your progress?

404. What are the individual tasks that relate to each of these milestones?

405. Which projects have you successfully completed in the past?

406. What have you learnt from the way you worked on previous projects?

407. Are there any areas that you have noticed you find particularly difficult?

408. What actions could you take to help with this?

409. Would a visual table like a Gantt chart help you to stay on top of each stage of the project?

410. What could get in the way of you completing this project?

411. What could you do to minimize this risk?

412. What would your ideal daily schedule look like to help you make progress while still maintaining balance across other areas of your life?

413. How do you actually spend your time each day?

414. What tweaks could you make to how you do things to get closer to your ideal schedule?

415. Are there any parts of your project that you could ask other people for help with?

416. How will you review progress of this project, to ensure you are meeting your initial aim?

417. What have you learnt from working on this project that could be helpful in the future?

418. Are there any incentives you could award yourself to help keep you motivated throughout?

419. Would it help you to block out chunks of time in your daily routine where you can work uninterrupted on this project?

420. If you knew you could not fail, what other projects would you start working on?

421. What do you most enjoy about project work?

422. How can you ensure that it is a success?

Junk Journals

A junk journal is a completely joyous type of journal to keep. The "junk" it refers to usually means that the journal itself is made from the types of paper that often get thrown away. This can include book pages, old maps, wrapping paper, envelopes, postcards, leaflets, magazines, pages from a notebook and anything else that might have been heading for your recycling pile. These separate pages all get bound together to make a completely unique journal.

Lots of independent retailers make and sell really beautiful junk journals, full of all sorts of wonderful goodies, but it is also great fun to make your own. There are some excellent tutorials available on YouTube, so it is definitely worth a look if you fancy keeping this type of journal.

You can write about anything you like in your junk journal. It can be the perfect place for jotting down ideas, inspiration or just a few notes from your day. I also like to stick in tickets, napkins, letters I have received, food wrappers and pretty much anything else that catches my eye.

Junk journals do not tend to have any formal structure – sometimes there is not even obvious writing space. This encourages you to get creative and find new ways of documenting your thoughts. I also find that it is a great place to add stickers, washi tape, stamping or any journal ephemera that perhaps does not suit the style of my other journals.

I like to add in lots of "interactive" elements, like cards that fold out, hidden journaling spots and pockets for sliding things into. A junk journal is probably the journal where I feel the most relaxed, as the complete lack of any structure enables me to play, document and explore all sorts of new ideas.

Layout #84

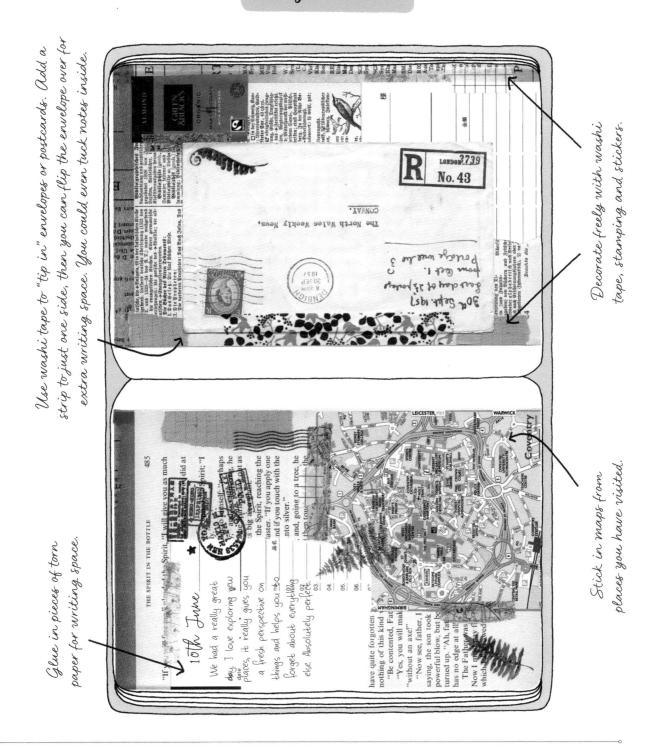

Use washi tape to "tip in" envelopes or postcards. Add a strip to just one side, then you can flip the envelope over for extra writing space. You could even tuck notes inside.

Glue in pieces of torn paper for writing space.

Decorate freely with washi tape, stamping and stickers.

Stick in maps from places you have visited.

Stick in a
paper doily.

Glue down pieces of decorative paper.

2nd May

A full-on work day. I
spent most of the
morning catching
up on emails and
also returning
phone calls. After
lunch I did
some filming
and started
working on
my next
blog post
for Friday.

MONT!!

AENT / YET LIST

VIRGINIA WOOLF ONCE wrote, but did
Statesman in which she proudly asserte
lived in Bloomsbury. "I ask nothing
for ever, and everywhere, should call me
"If they like to add Bloomsbury, W.C.1.,
and my telephone number is in the Direc
other reviewer, dare hint that I live in S
for libel." She was, responding
Mar 16, 1935, "the loomsbury b
were attacked as a gro highbrow
the attack back on the attackers: as far
to be a highbrow and respected lowbr
"who do not live in Bloomsbury which
which is on low ground, they live per
betwixt and between".
It is an odd cultural topography of
mus the Imperial College of
concert halls, a notable public librar
The original Kensington Manor can
the Confesor. William II took u
brilliant place of resort. In Kensin
cons ory, Queen Anne and Ge
there let s. Distinguished writers,
there perhaps by specifying *South*
differentiate the area around Bromp
ton to the north which had most o
torical association. But on the other
Ken a was that it was both m
self as one who wi stay of Blooms
concerned for the repectability of
Bloomsbury is safe for saddlebrow
South Kensington w not the rich
were to the north and west. One is
resented the richness of North and
South Kensington and by putting
symbolically located the richness a
it simply that she was born in K
specifying South Kensington she a
Virginia Woolf had a keen sense

Add a
pressed flower.

Try out a new art supply, such as paints,
pens or pencils, by creating swatches.
It is a great way to add a little colour
and document your new purchase.

Glue down a decorative napkin.

Tear up a sheet from a shopping-list pad to create space to write.

21st August

Worked really hard today, so decided to treat myself to an evening at the beach. We packed a picnic and drove off to somewhere lovely and quiet. It's so handy knowing the tucked-away spots. We took Barney with us and had a great walk along the beach and cliff tops. It was the perfect way to unwind.

22nd August

A successful day. Heard back on an exciting proposal and they want to go ahead – yay! I'm so lucky that I get to do so much of what I love for work. I never could have imagined this.

Use water-based ink to create an antique effect on plain printer paper and use washi tape to stick it down.

Add lots of fun decorations.

Layout #87

Use scrapbooking paper to create an interesting background.

Add photos.

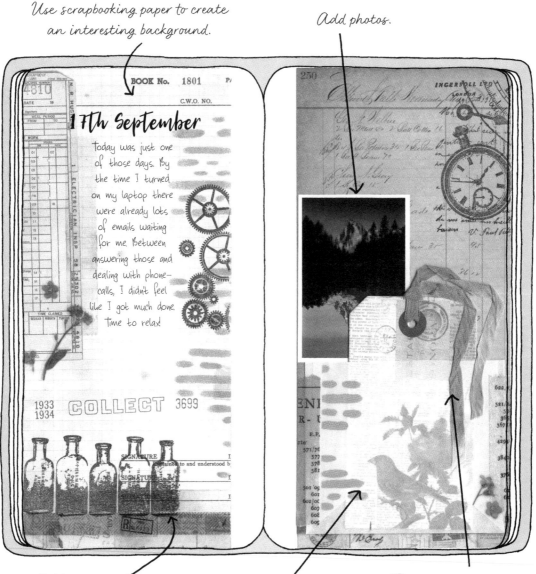

Add some stencilling and stamping.

Glue down a glassine/paper bag to create a pocket.

For private writing space, decorate a luggage tag and slip it into the pocket.

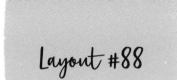

Layout #88

Cut a page from a magazine that really catches your eye.

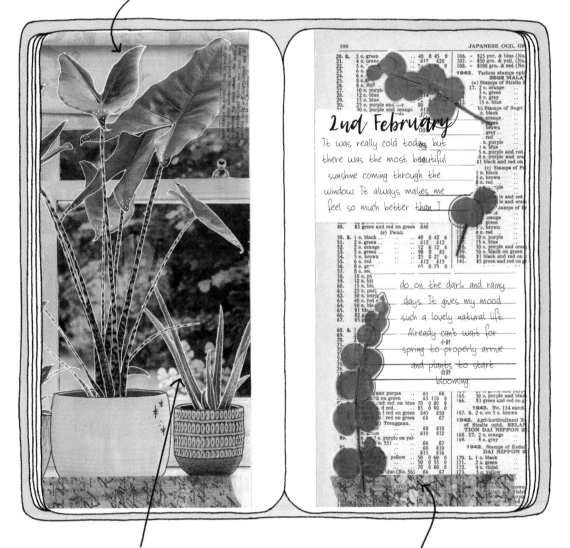

2nd February

It was really cold today, but there was the most beautiful sunshine coming through the window. It always makes me feel so much better than I

do on the dark and rainy days. It gives my mood such a lovely natural lift. Already can't wait for spring to properly arrive and plants to start blooming.

Use a white gel pen to add doodles and alter the look of the image for a fun effect.

Add stickers and washi tape to the opposite page to tie in with the theme.

Layout #89

Slot tickets, tags and pieces of paper inside the pockets so that you have plenty of space to write.

Add washi tape and stamping for extra decoration.

To add pockets to the page corners, cut right-angled triangles from scrapbooking paper.

Sew ribbon along the diagonal edge of the triangle, then sew or glue the other two sides to the page corner to create pockets.

WRITING PROMPTS

As you can use a junk journal for any type of journaling, I am including some more general writing and creative prompts to get you thinking.

Creative prompts:

423. What letters or postcards have you received that you could use inside your junk journal?

424. What items do you have in your recycling pile that could make great journal ephemera?

425. Do you have any maps or leaflets from days out that you could include?

426. What could you use to create some pockets in your journal?

427. Do you have any decorative napkins that would make a good background?

428. What magazine pages do you have that you could alter for including in your journal?

429. Do you have any tickets or tags that you could stick on your pages?

General journal writing prompts:

430. Who are you and what do you stand for?

431. How can you keep your mind clear of negativity?

432. What things help to keep you grounded?

433. What are your biggest frustrations?

434. What decisions or choices have you made today?

435. How do you feel about those choices?

436. In what ways is your journal routine helping you?

437. In what ways could you improve it?

438. Who do you secretly admire and why?

439. What are your guilty pleasures?

440. What things do you make harder for yourself?

441. What is the one thing you really want to achieve?

442. Where do you look for serenity?

443. Are you happy with how things are going?

444. What changes could you make?

445. What things make you angry?

446. Does that anger make any difference?

447. What annoys you most at the moment?

448. Do you think this thing will still be on your mind this time next month?

Fun Watercolour Pages

△▽△▽△▽△▽△▽△▽△▽△▽△▽△▽△▽△▽△▽△▽

Watercolour paint is a really versatile and fun art supply to use in your journals. Not many journals are made from watercolour paper, but I find that a lot of paper still holds up to this medium very well. The journals I use tend to have Rhodia or Clairefontaine paper, which will become wrinkled when wet, but dry out pretty nicely and return to being almost flat. They end up having a lovely crinkly noise when you flick through the pages, which is one of my favourite sounds!

It is worth trying out some watercolour at the back of your journal to test how your paper copes. You probably will not get quite the effect that you could achieve on proper watercolour paper, but it is still possible to create some really lovely looking backgrounds and illustrations.

In this section, I will be including lots of different techniques so that you can get started with watercolour right away, even if you are a complete beginner. There are great tutorials available online if you want to take your watercolour skills to the next level, but creating some beautiful backgrounds is a really fun starting point.

Mix different watercolour paints in a palette, using lots of water. Paint some loose stripes on your page. Work quickly so that the paints can run into each other.

Daily Journal – June

1st

A good start to the new month. I have a clear plan in place for what I want to achieve during June, and I'm really determined to stay on track. My biggest challenge is dealing with daily distractions such as emails and telephone calls. They can take up a lot of time and really disrupt my flow.

2nd

I've started putting time-blocking in place, so I only deal with emails at certain times of the day. This is really helping me to stay focused so far. Long may it continue.

3rd

I woke up really early, so I decided to get clear on my plans for the day and get cracking. I couldn't believe how much I got done before 9am. Maybe I should do it more often.

Once the paint is dry, add paint splashes on top.

Add washi tape and stickers for extra decoration.

Layout #91

Use three complementary colours to add a wash all over your pages. While still wet, sprinkle some salt over the paint.

When the paint is completely dry, rub off the salt. The salt will have absorbed some of the paint, leaving decorative white patches on your page.

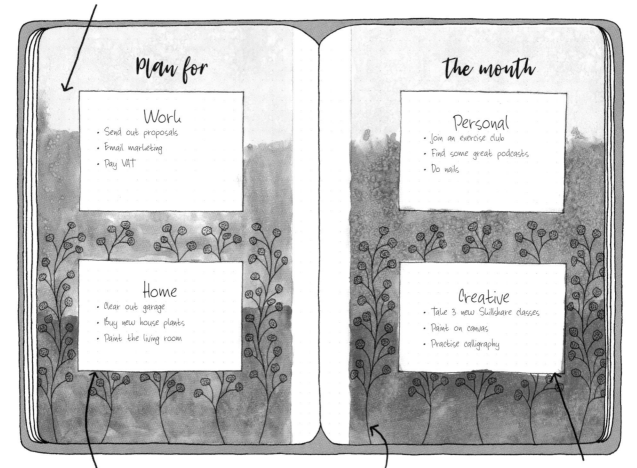

Plan for

Work
- Send out proposals
- Email marketing
- Pay VAT

Home
- Clear out garage
- Buy new house plants
- Paint the living room

the month

Personal
- Join an exercise club
- Find some great podcasts
- Do nails

Creative
- Take 3 new Skillshare classes
- Paint on canvas
- Practise calligraphy

Cut out four pieces of paper and use double-sided tape (or folded washi tape) to stick them to your journal page.

Add some fun floral doodles along the bottom.

Draw lines around your boxes for definition.

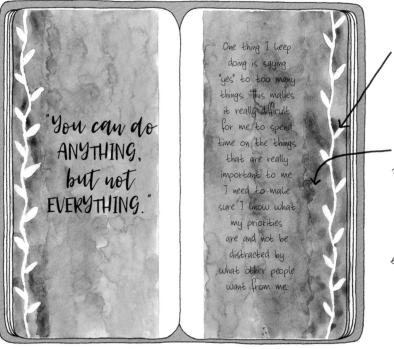

"You can do ANYTHING, but not EVERYTHING."

One thing I keep doing is saying "yes" to too many things. This makes it really difficult for me to spend time on the things that are really important to me. I need to make sure I know what my priorities are and not be distracted by what other people want from me

Use masking fluid to paint leaves running up the side of your pages.

Once the masking fluid is completely dry, add some washes of watercolour paint.

When your paint is dry, rub away the masking fluid to expose the white paper beneath.

Layout #93

In pencil, sketch a pot plant on each page, then paint, using darker shades to create shadows on the leaves.

Use a white gel pen to add extra details.

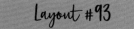

7th August
We went out to Totnes today and had a lovely time walking around the shops. They had some great market stalls too which were fascinating to explore. We found a lovely coffee shop for lunch and sat outside in the sunshine. Totnes has such a great quirky vibe about it.

8th August
Spent the day pottering around at home. Got some wash loads done, cleaned the bathrooms, and did a bit of gardening. Feel ready for the new week.

You can let some paints run together, as shown on the plant pots.

Choose three watercolour paints of similar colour, and mix each with plenty of water. Working with one colour at a time, drop lots of paint at the top of your page, then hold the page upright and gently tap it, encouraging the paint to drip down to the bottom.

"The future belongs to those who believe in the beauty of their dreams."

My dreams

- To have my own studio where I can easily do filming and creative workshops
- Live in a lovely detached character cottage, surrounded by woodland
- Earn all my income through creative journaling work
- Have a lovely natural cottage garden, filled with lots of beautiful flowers
- Spend my time working on projects that fill me with joy

Using the same colours, add lots of watercolour splashes on top.

Use a brush pen to letter out a quote that signifies what you will use this journal page for.

Layout #95

Stamp out some really bold images on your page, making sure you use a waterproof ink pad.

Plans for the

- Create a water feature
- Dig up space for a fruit and veg plot
- Buy outdoor fairy lights
- Plant hanging baskets
- Buy new recliners

garden

- Plant climbers along the back fence
- Paint the garden furniture
- Plant spring bulbs
- Decorate plant pots
- Jet wash patio

Use different shades of watercolour paint to bring your stamped images to life.

WRITING PROMPTS

As with junk journal pages, you can use watercolour pages as a background for any type of journaling. These general writing and creative prompts should help to give you some ideas.

Creative prompts:

449. Try sprinkling salt on wet watercolour. Let it dry and then rub the salt off.

450. Use washi tape to mask off areas before adding a watercolour wash.

451. Use masking fluid to create fun effects on your journal pages.

452. Try creating a page inspired by the colours that you can you see outside your window.

453. Create watercolour droplets by running paint down your page.

454. Add lots of watercolour splashes.

General journal writing prompts:

455. What things are you taking for granted?

456. How can you make more effort to appreciate them fully?

457. Where are your biggest areas of self-doubt?

458. What would happen if you chose to believe you would succeed at anything you put your mind to?

459. What significant events have had the most impact on your life?

460. Do the people you mix with make you feel better or worse about yourself?

461. How good are you at treating yourself kindly?

462. Listen to your thoughts for ten minutes and write down a free-flowing stream of everything that pops into your mind.

463. What can you learn from these thoughts?

464. What were your ambitions as a child?

465. How have these changed?

466. If you were your own best friend, what advice would you give yourself?

467. Write down something you are struggling with. Now try writing about it from a completely different perspective to see if a solution presents itself to you.

468. What did you do today to make you feel good about yourself?

469. In what ways do you undervalue yourself and your time?

470. What things have you spent time chasing that no longer seem valuable to you?

471. Where has your hard work paid off?

472. What limitations have you placed on yourself?

473. Where could you choose to lift those limits?

474. What negative stories have you been telling yourself? Write the opposite stories down in your journal and reflect on how you now feel.

Art Journal Pages

— · — · — · — · — · — · — · — · — · — · — ·

If you have days where the words just do not flow, but you still want to express yourself, then an art journal might be just what you need. Art journals tend to have quite thick paper and are perfect for adding lots of mixed media like acrylic paint, texture paste, decorative papers and thicker embellishments.

It is always worth adding a layer of gesso to your pages, which acts as a primer for your paper and creates a slight texture, making it the perfect base for acrylic paint.

When it comes to creating pages in your art journal, there are literally thousands of products to choose from, which can be a little overwhelming. I think a good starting point is some acrylic paint, gesso, stencils and texture paste. You can always add new supplies as you find techniques that you want to try out.

In this section, I will guide you through some of my favourite ways to get creative in your art journal, which hopefully will give you ideas to try out on your own. Follow the numbered steps in order to build up layers of texture and colour on your pages.

Sometimes I use my art journal to write out all my thoughts and worries on a blank page. I do not want anyone to read these, but still need to get them out of my system. I then create my art journaling on top of the writing, safe in the knowledge that it will be hidden from view.

Art journaling is a really expressive way to journal, as you can pick colours and imagery that represent how you are feeling without the need to write anything down if you do not want to.

Layout #96

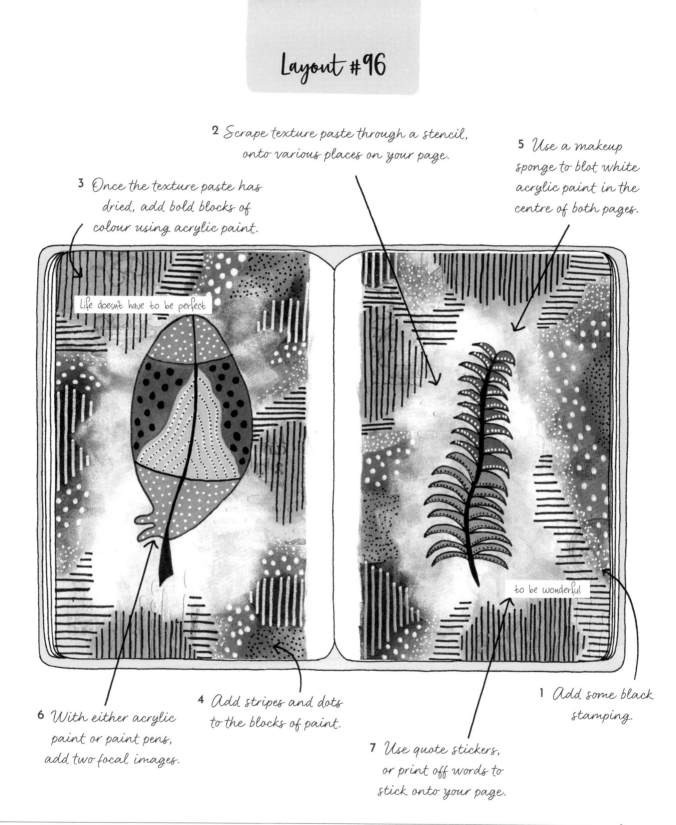

2 Scrape texture paste through a stencil, onto various places on your page.

5 Use a makeup sponge to blot white acrylic paint in the centre of both pages.

3 Once the texture paste has dried, add bold blocks of colour using acrylic paint.

Life doesn't have to be perfect

to be wonderful

6 With either acrylic paint or paint pens, add two focal images.

4 Add stripes and dots to the blocks of paint.

7 Use quote stickers, or print off words to stick onto your page.

1 Add some black stamping.

Layout #97

1 Add lots of background colour with acrylic paint.

2 Use a makeup sponge to push gesso through a stencil.

4 Add a quote.

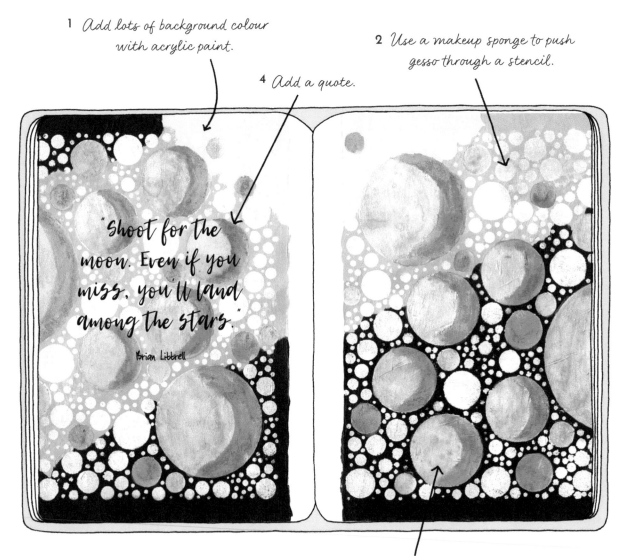

"Shoot for the moon. Even if you miss, you'll land among the stars."

Brian Littrell

3 Try using watercolour crayons to add colour to the surface of the gesso. Use a wet brush to spread the colour of the crayons and enable them to blend together.

Layout #98

1 Stamp black images onto the background.

4 Doodle flowers using a paint pen and fill in with acrylic paint.

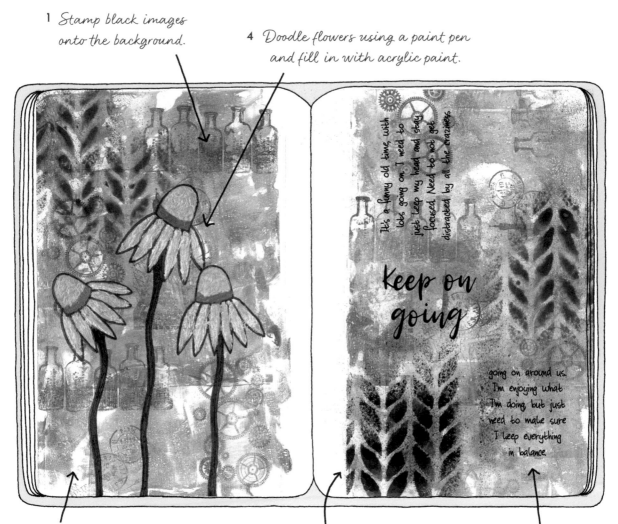

Keep on going

It's a funny old time with lots going on. I need to just keep my head and stay focused. Need to not get distracted by all the craziness

going on around us. I'm enjoying what I'm doing, but just need to make sure I keep everything in balance

2 If you like to use a gel printing plate, add some dots of acrylic paint to the plate — I have used two blues and a white. Use a brayer to smooth the paint out a little, then print directly onto your pages.

3 Using blue and black acrylic paint, stencil shapes over the background.

5 Add a quote and journal writing if you like.

Layout #99

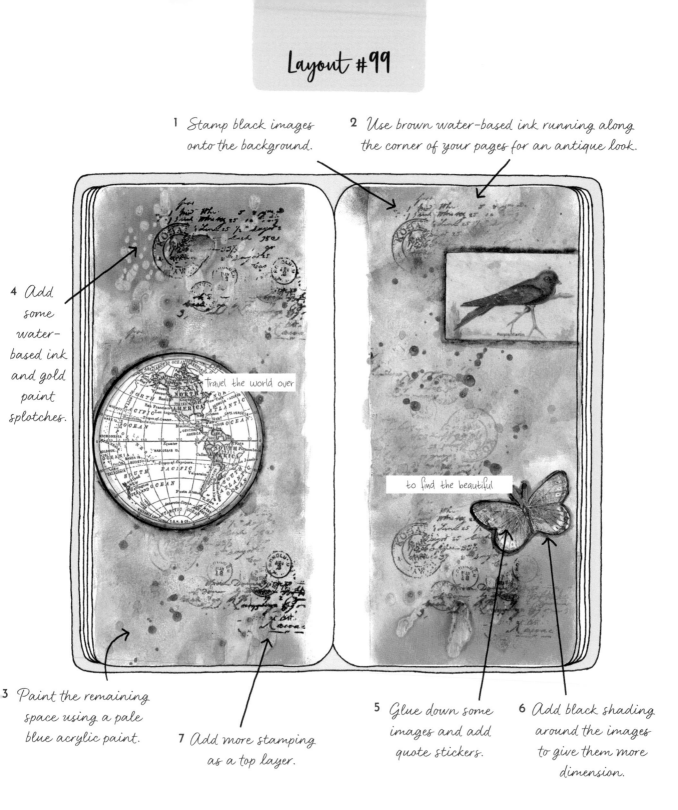

1 Stamp black images onto the background.

2 Use brown water-based ink running along the corner of your pages for an antique look.

4 Add some water-based ink and gold paint splotches.

travel the world over

to find the beautiful

3 Paint the remaining space using a pale blue acrylic paint.

7 Add more stamping as a top layer.

5 Glue down some images and add quote stickers.

6 Add black shading around the images to give them more dimension.

Layout #100

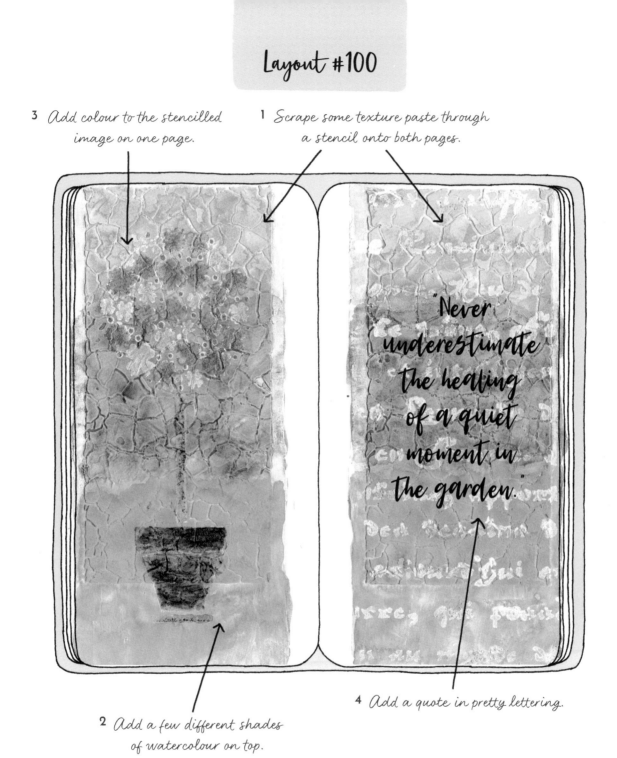

3 Add colour to the stencilled image on one page.

1 Scrape some texture paste through a stencil onto both pages.

"Never underestimate the healing of a quiet moment in the garden."

4 Add a quote in pretty lettering.

2 Add a few different shades of watercolour on top.

Layout #101

1 Roll out some red, pink and white acrylic paint onto a gel printing plate, then print this onto the pages.

2 Add doodle circles and marks.

3 Dip the edge of an old plastic ID card or similar in black and white paints to create lines.

4 Glue down torn book pages.

5 Glue down some gold flakes.

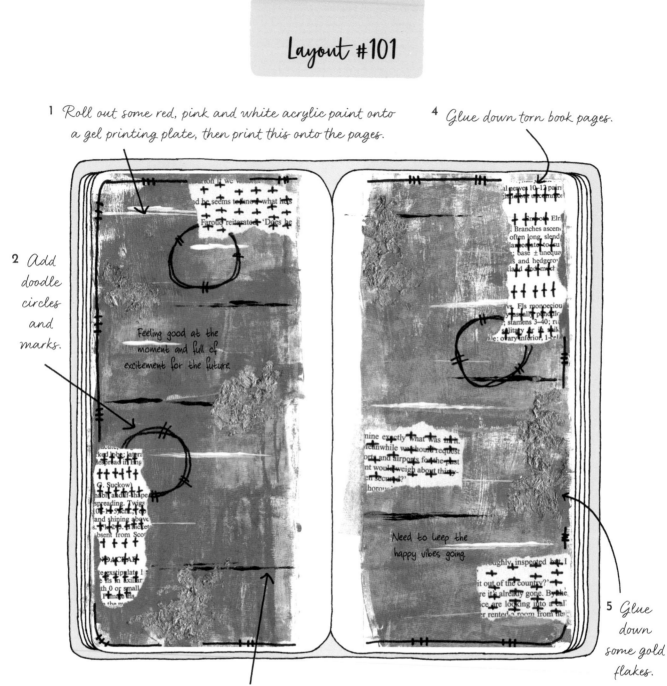

Feeling good at the moment and full of excitement for the future

Need to keep the happy vibes going.

WRITING PROMPTS

Art Journal pages tend to include lots of mixed media and colours, without much space to write. However you can still use your pages to tell your story and express yourself. I have included a mixture of creative and writing prompts to help you with this.

Creative prompts:

475. Apply texture paste through a stencil, to create an interesting look and feel to your pages.

476. Try applying acrylic paint using a makeup sponge or even your fingers.

477. Use a gel printing plate to create some really lovely backgrounds.

478. Use an old plastic ID card or other household items to create paint marks on your pages.

479. Try using paint pens for adding random doodles and line work.

480. Add gold flakes to your pages for a pretty effect.

General journal writing prompts:

481. What story do you want to tell with these pages?

482. What emotions are you expressing?

483. Do you want to vent a little and then cover the writing up?

484. What colours reflect your current mode?

485. Which feelings have you been supressing that you could safely express on these pages?

486. What things do you need to stop doing?

487. What should you be spending more time on?

488. What can you stop beating yourself up for?

489. Which challenges have you faced that actually ended up being your biggest opportunities?

490. Do you prefer to lead or follow others?

491. When do you most feel like you are on track?

492. How would you like people to describe you?

493. What can you do to make the most out of your current circumstances?

494. Which areas of your life need simplifying?

495. What is the most important thing to you in life?

496. What changes have you started to experience as a result of regularly keeping a journal?

497. What tweaks could you make to gain even more benefits from journaling?

498. Do you have any skills that you would like to learn to take your creative journaling up to the next level?

499. What time of day have you found it easiest to get some quiet time with your journal?

500. What are you looking forward to documenting or planning next on your journal pages?

About the Author

Helen Colebrook did not think of herself as creative until she found her "thing" – creative journaling – and began her blog *Journal with Purpose* (www.journalwithpurpose.co.uk). The freedom and lack of rules made journal-keeping the perfect hobby for her, and creativity has now become a very important part of her everyday life.

Helen's journal pages have been featured in various books and she has been interviewed for podcasts and for an article in the *Daily Mail*. In addition, her work has been featured by Cult Pens (part of the WHSmith Group) and was exhibited by Rhodia at The London Stationery Show. She has also collaborated with stationery brands such as Derwent, Edding, Faber Castell, Manuscript, MT masking tape, Royal Talens, Sheaffer, Staedtler, and Tombow.

Alongside sharing her journals on Instagram, YouTube, Pinterest and her blog, Helen runs journaling workshops online and in person across the UK.

Helen would love to see the journal pages you create using this guide, by tagging them on social media using #journalwithpurpose

Suppliers

Stationery Retailers

www.cultpens.com: Online retailer of a huge range of wonderful stationery items, including all of my favourite pens, pencils and notebooks.

www.startbaynotebooks.co.uk: My favourite brand of great quality leather notebook covers and journals.

www.londongifties.com: A fantastic stationery shop full of unique vintage paper goods, stamps, washi tape and hand-crafted watercolour paints.

Stationery Brands

Rhodia: great quality dot-page journals.

Royal Talens: offer a wonderful range of pens, pencils, acrylic paint, gel pens and art supplies.

Staedtler: great pigment liners for writing and sketching, along with a wide range of other lovely stationery items.

Tombow: a wonderful range of brush pens.

MT masking tape: washi tape.

Derwent: my favourite watercolour pencils.

Zebra: dual-ended pastel mildliners.

TWSBI: Diamond 580AL fountain pen.

Index

Printed in Slovenia by GPS for:
David and Charles, Ltd
Suite A, Tourism House, Pynes Hill, Exeter, EX2 5WS

10 9 8 7 6 5 4 3 2

Publishing Director: Ame Verso
Managing Editor: Jeni Hennah
Editor: Jessica Cropper
Project Editor: Claire Coakley
Proofreader: Jenny Fox-Proverbs
Design & Art Direction: Sam Staddon
Photographer: Jason Jenkins
Pre-press Designer: Ali Stark
Illustrations: Helen Colebrook
Production Manager: Beverley Richardson

David and Charles publishes high-quality books on a wide range of subjects.
For more information visit www.davidandcharles.com.

Share your makes with us on social media using #dandcbooks and follow us on Facebook and Instagram by
searching for @dandcbooks.

Layout of the digital edition of this book may vary depending on reader hardware and display settings.